ICONS IN CZECHOSLOVAKIA

HEINZ SKROBUCHA

Icons in Czechoslovakia

PHOTOGRAPHY BY LADISLAV NEUBERT

HAMLYN

LONDON · NEW YORK · SYDNEY · TORONTO

Text by Heinz Skrobucha
Photography by Ladislav Neubert
Translation of Introduction by Neil Morris
Translation of Notes to the Plates by Simon Pleasance
Graphic Design by Václav Jedlička
Designed and produced by Artia for
The Hamlyn Publishing Group Ltd.
London • New York • Sydney • Toronto
Hamlyn House, Feltham, Middlesex, England

Printed in Czechoslovakia
ISBN 0 600 02005 3
29905-51

Almost all languages contain an extensive literature on the subject of icons, and it would therefore seem superfluous in this volume to go deeply into the icon as a phenomenon with all its many aspects. A short synopsis might, however, be useful as a reminder of some of the more important criteria or as an outline of the general basis of the theme for readers less familiar with the subject.

As regards their artistic form, the earliest icons known to us are linked with Late Antiquity art, and more precisely with the portrait and the historical painting. The portrait adheres above all to the representational picture, as a painting of the emperor for example, or a picture of the deceased in the case of sepulchral art. Portrait panels, which were placed upon the heads of mummies in Fayum during the Roman rule of Egypt, are often taken from this latter group of pictures and compared with icons, sometimes in a much oversimplified manner, or even declared as their precursors.

But at first the Christian pictures – the pictures of bishops, for example, which are testified in fourth-century literature—lack any character of worship. A reverence for these pictures seems to appear in the fifth century and is testified increasingly from the sixth century onwards. This development was watched with concern by the hierarchy of the Church, especially since the limits of admissible reverence were frequently exceeded by people belonging to the Church, and iconolatry showed questionable parallels with heathen idolatry.

This problem was settled with all severity in the so-called iconoclasm, towards the conclusion of which the binding view of the Church was formulated in the Seventh Oecumenical Council, the Second Nicaenum (787/88). The power of worship of the icon was derived from its ability to preserve a similarity to the archetype, and therefore the person represented, and to become its valid representative. In this way the painter of icons is bound at the same time to archetypes which transmit the appearance of the person represented, whether it be real or simply declared to be real. It is certainly not a matter of chance that fragments of a text from the ninth century have been preserved, in which the appearance of a number of figures from the Old and New Testaments is described. These descriptions, which were meant to form a basis for the preservation of a similarity to the archetype, are to a certain extent precursors of the later painting books. Such a painting book (Greek *hermeneia*, Rus-

sian *podlinnik*)—like that of Dionysius of Phourna, the so-called Athos Book—could consist simply of passages from texts, in which the appearance of the saints and the basic composition of scenes were described, or it could—like the so-called Stroganov School Book—contain outlines of the saints and church festivals for the year, to which were added notes on the inscriptions to the picture and on the colours.

It should be borne in mind, however, that right through to modern times this tradition was not regarded as a scheme to be followed slavishly, for painters saw it as a framework allowing them a certain limited amount of scope for their own design; they knew how to get the most from such a framework, and this they did in masterly fashion as regards both composition and colour. This appreciation of tradition as a spiritual continuity made it possible for painters, even in works which were so bound to the absolute, to express the spirit of their time, the taste of those who commissioned their work, and the specific spirituality of their people. The state of icon-painting in Greece and in the Christian Balkans during the centuries-long Turkish rule clearly demonstrates that social and class relations exert an influence upon art. At the same time it shows that art and culture can become enriched and enlarged only through contact with other cultures, an example of this being so-called Italo-Cretan painting and art on the borders between Occidental and Orthodox Christianity in Eastern Central Europe.

As in most countries outside the realm of Orthodoxy, both the public and private collections in Czechoslovakia are found to include Greek icons dating from post-Byzantine times and Russian icons from the sixteenth century onwards, when the Muscovite State became consolidated and the regional centres gradually lost their meaning in relation to Moscow.

With regard to post-Byzantine art, two plates from a series of church festivals in the Prague National Gallery deserve special mention: one represents the Nativity (Inv. No. DO-3391), the other the Entry into Jerusalem (plate 1). They are works belonging to the Cretan School from the second half of the sixteenth century. The composition of the themes is clearly formed and harmoniously constructed, the figures are lifelike and individually reproduced, the drawing is precise and the graceful movement of the lines has an added decorative effect on the trunks and branches of the trees, the borders of the garments and the saddlery of the horses. The walls, roofs and towers in the

VI

representation of Jerusalem are attached and joined to each other in an artistic manner. The strictness of centuries of tradition is relaxed a little by certain traits typical of the genre: the scuffling children in the icon of the Entry into Jerusalem, the playful jumping of the horses at the feet of the attendant with the Christ Child on her lap, the youth sitting and playing the shawm with his back to the grotto, and the changing movements of the animals tended by the shepherds in the icon of the Nativity. In the icon of the Pietà (Inv. No. DO-3393), which is also sixteenth-century and derives from the Greek cultural society which from 1210 belonged to the Venetian dominion, sorrow and grief are emphatically reflected in the faces and bearing of the Virgin, Mary Magdalene and the youthful St John. The garments are embroidered with tendrils and flowers, and the haloes are interlaced with leaved tendrils. The painter of this Pietà shows himself to be quite familiar with Italian art, and sparing, carefully selective use of its means allows him to intrude unobtrusively into Byzantine canon.

The Byzantine heritage dominates to a considerable extent throughout the seventeenth and eighteenth centuries, above all in the basic iconographic conception. As regards detail, however—whether it be landscape and architecture, or drapery and ornamental forms—the painter turns more and more towards his contemporary environment. Additional attributes towards the characterisation of individual saints are incorporated from Western art, an example of which is the representation of Mary Magdalene on a Hodegetria icon of the Virgin with seven saints, which comes from a workshop on the Greek Islands, of approximately 1700 (Inv. No. DO-4873). But on the Greek mainland, which was severely oppressed by foreign Turkish rule and where cultural life lacked the direction of blooming cosmopolitan towns, such as existed in Crete and the Ionian Isles, painters from the villages and workshops of the poor monasteries, who were without patrons or people to commission their work, took great active interest in the Christian picture. They often invented different forms of expression which, in certain archaisms, in naïve simplicity, and here and there in folkloristic adaptations, make even the observers of today forget their weaker artistic merits. In their carefree manner they occasionally try to extend the theme according to their own ideas and to correct it by using their imagination. An example of this is to be found in an icon from northern Greece of the second half of the eighteenth century (Inv. No. 0-8316), which depicts the Ascension of the Prophet Elijah. This picture includes the scene of

the Prophet with the ravens; but here Elijah sits in the shadows of a tree, not before a cave in the rocks, and not only one raven flies down to him with the manna, for another is added carrying some remarkably formed piece of food, which could be a fruit or a fish. And while Elijah turns down towards Elisha from the high, artistically carved chariot, the hand of God holds the reins of the fiery horses. Elijah's robe is not the torn old cloth of an ascetic, but is lined and trimmed with fur and richly embroidered on the outside with tendrils and ornamentations.

In order to add embellishment to icons, it becomes the custom more and more from the seventeenth century onwards, not only to furnish the outer borders with carved ornamentations, but to finish the painting surface with artistic *rocailles* by means of carving or joining. An icon with such a finish is the Mother of God in the style of 'the rose which never fades' (Inv. No. DO-3370) from the first half of the eighteenth century. The Trinity of the so-called New Testament genre is painted on the head-piece; a knotted ribbon is carved around the edges and encloses the six circular medallions with the half-length portraits of the prophets; on the lower edge of the picture the holy Bishops Charalampes, Athanasios and Nicholas are represented in three carved niches. From the Balkans only a few icons deriving from eighteenth and nineteenth-century Rumania and Bulgaria have been collected, which will only be alluded to here.

Russian icon-painting, however, is represented with a number of good, typical works, which come for the most part from the famous Soldatenkov Collection. A grand icon of the Virgin Hodegetria of the Smolenskaya type (Inv. No. DO-3394) can be placed at the end of the fifteenth century and attributed to the Muscovite School. A small icon depicting the Pantocrator on the throne (plate 5) can also be attributed to the Muscovite School and the beginning of the sixteenth century, and this was undoubtedly the central piece of a domestic iconostasis, from which three more plates (John the Baptist, Peter and Paul) are to be found in the collection of the Recklinghausen Icon Museum. A small plate depicting Christ's resurrection and ascension (plate 4) also belongs to this period, and this could well be attributed to the Muscovite School, although it contains recognisable elements of the Novgorod painters. This process of the incorporation of the local schools—or at least a large number of them—into an imperial art centering around Moscow can also be clearly recognised in three festival icons: the Annunciation of the Virgin

(plate 8), the Holy Women at the Sepulchre (Inv. No. DO-3401) and The Doubting Thomas (plate 7). Typical of this group of pictures is the elongation of the figures, the subtly harmonious construction, the subdued colouring reminiscent of the great age of Novgorod, and the influence of certain mannerisms.

The sixteenth century is represented not only by works from the Moscow region, however; the National Gallery in Prague also possesses some examples from the wide area north of the capital belonging to the middle and the second half of the century. With its forcefulness of statement and its simplicity of execution, an icon depicting the two Saints, Prokopij of Ustyug and Varlaam Khutynskij (plate 9) has a corrupting effect. While these two saints are turned sideways towards each other and a medallion of Christ Emmanuel is painted on to the upper edge of the picture, the painter has adhered to the frontal position, which had been favoured in previous centuries, in another group of two figures, that of St John the Evangelist and a Holy Warrior (plate 10). This icon also originates from Moscow, but the construction of the figures is reminiscent of icons of northern Russia. Once again we have a picture of an individual saint as an example of the end of the sixteenth century: St Paul Obnorskij (plate 6). In his laconic artistic style the painter succeeds here in representing the ascetic and founder of monasteries in a way which, it would seem, could not be more authentic.

The sixteenth century is also characterised by another development, namely the augmentation of representations filled with many different scenes and figures. In these icons the painters do not aspire to the inaccessible, the absolute, but attempt to give detailed pictorial information about an occurrence, which can serve both construction and instruction. This tendency, the many-layered cultural-historical, church-historical and social bases of which cannot be investigated individually, comprises also the inclusion of new themes, which before had been dealt with only rarely, if at all. They derive from monastic literature, from the great wealth of sermons, from liturgy and hymnology, and also occasionally from the Occident; not the least contributory factors were the activities of Western artists in Russia and the spreading circulation of printed illustrated books.

An icon of the early seventeenth century depicting the birth of the Virgin (plate 11) may serve as an illustration of the new methods of design. The prayer of Joachim and Anne, their meeting at the gate, Anne resting after the

birth, the bathing of the child and the parents' caressing of the child—all these are included and joined together within the picture. A narrow strip of ground, with grass and birds around a well, concludes the picture. It is obvious that a refined improvement in drawing should go hand in hand with this new tendency, and this can be seen in a series of icons from the end of the sixteenth and the seventeenth century: John the Evangelist with Prochorus (plate 12), the Nativity (plate 13), and Christ reading Abgar's epistle (Inv. No. DO-3346). It also continues into the eighteenth century with the icon 'Only-begotten Son, Word of God' (Inv. No. DO-3360), the Virgin of the type of the burning bush not consumed by fire (Inv. No. DO-3377) and other works of the modern era. An example of the conscious assimilation into later icon painting of the secular portrait of Western origin is the icon depicting Saint Mitrofan, the first bishop of Voronezh (Inv. No. DO-3384). The varieties and changes of artistic forms of expression are therefore plainly represented in the large group of Russian icons in the National Gallery, Prague.

Czechoslovak territory, above all East Slovakia, contains an Orthodox population which has settled for centuries in closed colonies, and there is a smaller group in the Komárno area. For the source of this latter, smaller group one has to hark back to the Serbian migration northwards in 1690. When the imperial troops were able to push the Turks back across the Balkans after the liberation of Vienna (1683), the Serbian patriarch found himself eventually, but only after a great deal of hesitation, in a position to call his country's Christian population to do battle against the Turks. Austria could not hold the occupied areas, however, and when her troops retreated, 36,000 families lost their homes and sought protection in the Empire from the revenge of the Turks. In 1716 the Serbian patriarch took up residence in Sremski Karlovci. Parts of this flood of Serbian refugees penetrated into what was then northern Hungary and the Komárno region, and the Orthodox Church in this area became an obvious expression of their colonisation. In this Church and the museum covering the area around the Danube one finds some icons even to-day, mostly works from the eighteenth and nineteenth centuries, and partly with strains of folklore influence. One of the icons of the greatest quality from this area is The Raising of Lazarus (plate 3), signed by a painter named Georgios.

Of even greater interest are the icons in East Slovakia, some of which are still to be found there today in the churches, many of which are made of

wood, while others are in the possession of various museums. Those most deserving mention are: the Museum for the Šariš District in Bardejov and the Open-air Museum in Bardejovské Kúpele; the Slovak National Museum in Bratislava, which has included icons in its collection since 1968; the East Slovak State Museum in Košice; the Museum for the Zemplín District in Michalovce, which contains a small number of icons from East Slovakia; the National Gallery in Prague, in which some icons from the Carpathian region are also to be found, and the Museum of Ukrainian Culture in Svidník, in which there are some masterly works from the Carpathian region, as well as eighteenth- and nineteenth-century icons imported from Russia. Regional museums in other East Slovak towns also contain one or two icons, but they are mainly late Russian works, as are to be found in Prešov and Sabinov, to give but two examples.

* * *

Icons in East Slovakia — this phrase should not be equated with 'East Slovakian icons', which would also embrace the origins of these works in East Slovakia. All that is meant is the area in which these icons have fulfilled their function in churches through the centuries. The question as to whether these icons arose here originally, and from which period onwards local artists actually produced icons, will be dealt with later. It must be remembered that only recently has research been carried out into both medieval and modern religious painting by the Orthodox peoples in the Carpathian region, and that this research has resulted in the formulation of lines of development rather than concrete detailed patterns.

The prerequisite to an understanding of this problem is the clarification of the historical, ecclesiastical and ethnological background to the material culture of this region. Such an examination cannot be based on present-day political boundaries, of course, but must take into account the fact that Slovakia was an integral part of the kingdom of Hungary from the time of Hungary's annexation of this territory at the beginning of the tenth century until the disintegration of the Austro-Hungarian Empire at the end of the First World War. The Polish frontier remained unchanged for more or less a thousand years, if one disregards the pledging of the mountain towns of Spiš to Poland. This territorial continuity and the predominantly neighbourly relationship between Hungary and Poland created the best possible provision

for cultural interconnection, especially since the borders which existed in the Middle Ages and early modernity in this part of middle-eastern Europe were by no means impassable. The wooded region of Carpathia provides numerous passes, which allowed of and facilitated traffic over the mountain ridge.

This north-eastern verge of the kingdom of Hungary has always had a sparse Slovak population. The Hungarians themselves have always seen this area as a protective zone against invasion from the East and have consequently never settled there. Some time in the fifteenth century wandering herdsmen came from the South to the Carpathian region, and this so-called Walachian migration continued for the next few centuries. These people wandered over the ridge of the Carpathians into Polish territory and reached the area south of Cracow. The term 'Walachian' should not be used in a narrow sense, for closely connected with the Walachian groups were other Balkan-Slav peoples such as Bulgarians and Serbs, and even Albanians. In the course of time some of these wandering herdsmen settled, turned to the more profitable timber trade and stayed in the narrow valleys. Some of them are known in the Carpathian region as Lemks, Bojks and Huzuls. Settlers from Southern Russia also crossed the Carpathians and stayed on the western slopes and in the western foreland; and, under pressure from the Turks, Hungarians made for the Carpathian foreland.

There are various names for the non-Slovak Orthodox peoples in this area. In the kingdom of Hungary the so-called schismatic inhabitants of Slavic origin, who did not belong to the Roman Catholic Church, were usually called Ruthenians. This name was kept up during the time of the Austro-Hungarian Empire. There also arose terms such as 'Rusnjakians' and 'Rusinians', and after the advent of the Ukrainian national movement the term Ukrainians was used; this was often narrowed down even further to Carpatho-Ukrainians.

The Orthodox population of East Slovakia came under a bishop in Muka-chevo, who is first mentioned in documents of 1491. The exact boundaries of the bishopric are not known, and there are only hypotheses concerning the jurisdictional membership of the bishop and his union with Rome. But we know for certain that no such union existed in the sixteenth century, for it is established in a document of 1574 attributed to the Emperor Maximilian II that Ruthenians and Walachians were exempt from paying tithes to the Catholic clergy, as they paid them to their own priests. These priests for the

Ruthenian population came for the most part from the Orthodox regions of Poland and were often ordained by the Bishop of Przemyśl.

When the Orthodox hierarchy of Poland confirmed its union with the Holy See at a synod at Brest in December 1596, it was obvious that this decision would also have an influence upon the situation of the bishopric of Mukachevo. To achieve the same status as the priests of the priviledged Roman Catholic Church was, with the oppressive commercial and social situation, naturally an aim worth striving for as far as the Orthodox clergy in Hungarian territory was concerned. The first efforts concerning the clergy of the bishopric of Mukachevo were made in 1613–14 by the Bishop of Przemyśl, Athanasius Krupecky, who belonged to the union. Bishop Vasilij Tarasovich of Mukachevo made the first attempt in 1642 to take his bishopric into the union, but the clergy denied him allegiance. Four years later, on April 24, 1646, sixty-three priests announced their union with Rome in Uzhgorod. They were basically representative of the clergy from the northern parts of the bishopric, that is more or less the area which corresponds to the present-day East Slovakia. The southern and south-eastern areas, on which the political power of the feudal lords, and particularly that of the Rákóczi family, exerted a restricting influence, remained outside the union to begin with. Not until 1759 was the Bishop of Mukachevo, Michael Olshavsky, able to report to the Holy See that there were no more 'schismatics' within his diocese.

This is not the place to give details of the development of the union and the difficult path towards the realisation of hopes which was related to this. We must simply refer to the work of Michael Lacko and others, who have dealt with this theme extensively and with deep documentation. It must be remarked that the difficult jurisdictional arguments between the united and the Roman Catholic clergy were settled on September 19, 1771 by Pope Clement XIV's bull, in which he founded the diocese of Mukachevo and ensured its independence. As the territory covered by the bishopric proved in the course of time to be too large for the administration of one bishop, a new See was created in Prešov by a proclamation confirmed secularly by Emperor Francis I in 1816 and canonically by Pope Paul VII on September 22, 1818. Almost the whole of present-day East Slovakia became the responsibility of this new bishop.

The union with Rome, which was carried out by a calm assessment of the situation and was scarcely comprehended by the church people because of their extreme poverty and lack of education, was completed before the back-

ground of the re-Catholicisation of Hungary, which towards the end of the sixteenth century was radically reformed and became ninety per cent. Protestant. The unrest and uprisings carried over to the Carpathian region. When Bishop Vasilij Tarasovich of Mukachevo died, the clergy chose the priest Parthenius Rotoszinsky as his successor in 1651. At the news that the Rákóczis wanted a non-united, Orthodox, pro-Protestant successor for the deceased bishop, the clergy thought it best not to wait until confirmation of the appointment of Parthenius arrived from Rome. He was therefore sent to the neighbouring Rumanian region, where the Orthodox — and therefore schismatic — bishops Stefan Simonovich of Alba Iulia, Gregor from Moldavia and Sava of Bistritza consecrated him as a bishop. Parthenius requested and received, by the agency of the Bishop of Esztergom, absolution from Rome for his irregularity, and was confirmed in 1655. This episode not only characterises the disorderliness of the situation at that time, but also serves as an indication of the constant machinations of the bishopric of Mukachevo.

Poland should be mentioned here, for slight relationships existed there both before and after the union and in the eighteenth century the consecration of the Bishop of Mukachevo by the united bishops was often conducted there. The resolutions reached at the provincial synod of Zamóść in 1720 (documented by Pope Benedict XIII on July 19, 1724) — to promote piety and education amongst the clergy and the people, to implement essential changes in ministerial practice, and to decide on the function of the Iconostases in the churches — had their effect in the Carpathian region belonging to Hungary. Present-day Rumania must also be mentioned, the northern parts of which were immediate neighbours (i.e. Transylvania, Maramures, Moldavia), and whose united bishops (Fogaras) also performed the consecration of bishops of Mukachevo. As the imperial deputy the Bishop of Mukachevo, Michael Olshavsky, successfully subdued the Transylvanian uprising in the middle of the eighteenth century, which had led to the temporary dissolution of the united priests there. Southern Russia, which became part of the Muscovite state in 1654, is also important; particularly Kiev, mainly because of the efforts of Archbishop Peter Mogila (in 1633–47) and his founding of the Kiev Ecclesiastical Academy.

The background to a study of icons in East Slovakia has now been outlined. The icons originate in the main in the wooden churches of Carpathian villages, and many still have their place there today. It would seem — and the poverty

of the people of that area at that time makes it understandable — that icons were present only in churches and not in private homes. In the nineteenth century prints, and, occasionally, framed pictures might well have taken the place of domestic icons. Unfortunately only a few icons from early times have been preserved in churches; the course of time has taken its toll of many of them, a great number of which were no doubt lost when the present-day wooden church, which had its origins in the eighteenth century, took the place of its predecessor. The old, probably more plain Iconostases were replaced by new Baroque constructions, which require different and often smaller formats. Sometimes the icons of the old Iconostases were hung on side walls of the church or on the gallery, and in many cases in the apse, in order not to disturb the uniform furnishing of the new form of Iconostasis.

In the introduction to the exhibition catalogue of the Slovak National Gallery in Bratislava ('Icons in Slovakia', 1968), Štefan Tkáč speaks repeatedly of 'East Slovakian icons' and 'East Slovakian icon painting'. It is in fact questionable whether native artists were active in the Slovak Carpathian region before the eighteenth century. There are no written sources to confirm this, and those pre-eighteenth-century pictures which have signatures or inscriptions refer to the Polish Carpathian region and sometimes name even the village and the church for which they were intended. Even if the icons with such inscriptions are the exception, a study of the style and colouring of the paintings shows that they correspond to the numerous icons of the same period which are to be found in the museums and churches of present-day Poland (Cracow, Sanok, Przemyśl, Nowy Sącz) and the Ukraine (especially Lvov).

The icons in the churches of East Slovakia cannot therefore be looked at in isolation or as the work of one particular school of painting, but form a part of the painting of the whole Carpathian region. They belong within the scope of the icon painting which is designated as Galician or Ruthenian, or Ukrainian today. As up until the eighteenth century they did not originate in the same region as that in which they finally appeared, they reflect the development and influences which are typical of their actual region of origin.

Despite the great deal of research carried out in Poland, Rumania, Czechoslovakia and the Ukraine in the last few years, many of the questions regarding the centres of this painting remain unanswered, and much intensive and detailed work will be needed in order to reach concrete solutions. A great

deal will undoubtedly remain uncertain and hypothetical. For a classification of icons in East Slovakia an arrangement according to periods would lead to more reliable results than an attempt at arrangement according to local workshops.

The first group must comprise the icons before the middle of the first half of the seventeenth century, in which the continuity of old traditions of icon painting was preserved. From this time until the middle of the eighteenth century two tendencies can be quite clearly distinguished; the first is based upon a continuation of the old tradition but does not always escape a certain 'desiccation' and coarseness; the second shows a definite receptivity towards Occidental forms and the onset of an assimilation of the art of the Roman Catholic environment. From the middle of the eighteenth century onwards both tendencies become stronger; in the case of the first group this leads to a folklorist design, and in the case of the second to a Western kind of devotional picture in the nineteenth century, which remains an icon in function but is closer to the Occidental religious picture in artistic statement.

The icons of the first group (plates 14–27) are documented mainly by pictures from the old Iconostases of the churches in Rovné, Uličské Krivé, Krajná Bystrá, Lukov-Venecia, Dubová and Príkra, some of which remain in these churches today and some of which are in the museums at Bardejov and Svidník. They are dominated by the Byzantine canon. This base of hieratic representation, stamped with internal dynamism and external monumentality, leaves room for the expression of the aesthetic ideas of the Carpathian region, but also for the manifestation of the stages of intervention mentioned previously. At this time of the Turkish advance in South-East Europe the artistic forms and iconographical details of painting in Greece, Serbia and Bulgaria were spread into Central and Western Russia by wandering artists. The Serbian and Bulgarian influence on Russian painting — in Novgorod, Pskov and even Moscow — are well-known. The Serbian monk, Nektarij, painted the frescoes in the church of Supraśl in present-day North-Eastern Poland some time in the second half of the sixteenth century. Byzantine-type frescoes of the fifteenth and sixteenth centuries in other Polish churches such as the chapel in Lublin (1418), the Chapel of the Holy Cross in the Wawel at Cracow (after 1470), the collegiate churches of Wiślica and Sandomierz (about the beginning of the fifteenth century), the Onuphrius Church at Lavrov near Lvov (fifteenth century), and the Wirmenska Church in Lvov (sixteenth century) — to name

XVI

but a few important examples — confirm a basic knowledge of the art of Greece, Russia and Serbia in those centuries in the Poland of that time. This finding remains undisturbed by the unsettled question of the origins of the painters of these frescoes, whether they were foreigners (Russians or Serbs) or natives of the Orthodox region of what was then Southern Poland.

The icons before the turn of the seventeenth century show high technical ability on the part of the painters, quality of painting and sureness of composition. They could have originated in workshops in towns or in monastic workshops in the vicinity of large towns, in which case we should probably think of Lvov, Sanok or Przemyśl, and not so much, it seems, of Kiev.

If we examine some characteristics of these early icons, which remain valid in different forms up to the eighteenth century, we must first of all mention the delight in ornamentation displayed by the golden backgrounds. Gold does not simply form a neutral surface, but is animated by incised or relieved ornamentations. Simple or double strips connect the whole background in a dense pattern of small figures (rectangles, squares or rhombuses), the centre of which is adorned with a circle or a plain rosette. An incised or relieved tendril is often to be found in haloes also.

One finds such ornamental design of the background in the peripheries of early Byzantine art. Relieved ornaments on icons are certainly not rare in Cyprus; they can be seen, for example, on a thirteenth-century double-sided icon representing the Crucifixion (in Nicosia), and on a fifteenth-century icon depicting Christ in the Temple (in Famagusta). A thirteenth-century icon of the Apostle Paul (in Nicosia) has embossed ornamentations in the haloes, and these were quite widespread amongst the Greek painters in the dominion of Venice after the Fourth Crusade. This type of design on icons was probably stimulated by Occidental influences. In the Carpathian region these forms of ornamentation with all their variations could have been taken over from non-Orthodox art. To give just one example: the ornamental design of the background to the depiction of Christ's Descent from the Cross on the polyptych in the Andreas Church in Olkusz (B. Przybyszewski, 'Powstanie i autorstwo poliptyku Olkuskiego', in Folia historiae artium II, Cracow 1965, p. 84, fig. 1), which is dated 1485, is more richly shaded than that of the middle section of the Deesis-row in the church at Rovné, which is very simply stylised. But the influence of Gothic panels on the design of the backgrounds to these icons is quite obvious. This is also true of other forms of ornamentation; the

rich patterns of leaves, tendrils and flowers on other and later icons, which also tend towards Occidental influences.

A formal, compositional singularity is also worth mentioning. On the icons depicting the Saints or the Archangel Michael, on which their lives and deeds are represented in a cycle of individual scenes, the upper edge above the central figure is left uncoloured. In Russian icon painting it was usual to place this row of scenes around the central space, in which the Saint appeared either half- or full- length. On the icons of the Carpathian region, only the sides and the lower portion are used for a biographical rending. This also applies to icons depicting the Mother of God with the Child, around the edges of which the prophets are represented (plate 24). Related forms of composition are to be found on Bulgarian icons, which use only the two side strips for scenic representations, whilst on icons of the Virgin Mary a Deesis is painted on the upper edge above the Mother of God. On sixteenth-century Rumanian icons of the Virgin Mary the painter often used both side strips for the figures of the prophets, leaving the upper and the lower edges empty.

The colours on the icons of this early group are bright and powerful: deep green, shining red and majestic blue. They form a delightful composition and are often reminiscent of the colour-values of Novgorod and Pskov. Additional tones are to be found on many icons of the Carpathian region in the stylised suggestions of grass and shrubs on the lower strip of the foreground. White and broken reddish shades are favoured colours for these decorative motifs. It is still not known today whether there is some connexion between these tufts of grass and flowers of the Carpathian region and the more abstract, star-shaped, line and circular patterns which appear even on the lower strip on a number of Novgorod icons.

It is not by chance that the end of this early, if you like, Classical period of icon painting in the Carpathian region more or less corresponds with the termination of the union of Brest. The period of the United Church of Poland which now begins is more strongly characterised by the assimilation to the Roman Catholic Church than was the case in the previous centuries, during which time the union was prepared. Great pains were taken to achieve the assured equation with the Roman Catholics and thereby to preserve the traditional rites. In the Kiev region, on the other hand, the Orthodoxy was consolidated by the renewal of the Constantinople organisation of the Churches (1620) and by the influence of the energetic Archbishop Peter Mogila (1633–47).

But his reforms also took on Occidental humanism and led to a deepened knowledge of Western theology, even if this had the aim of getting to know learning and arguments which were to be opposed. Although the point of these studies was not to bring about an approach towards Catholicism, they led to greater open-mindedness and influenced spiritual life indirectly.

As far as icon painting was concerned, this development meant the beginning of a certain duality. One section of painters felt itself bound to the old traditions, but in time fell behind with regard to contemporary taste — especially that of the leading classes in the Church and society, who were orientating more and more towards the art and culture of their 'priviledged' surroundings. The other painters showed themselves to be receptive towards the new possibilities and increasingly approached the Occidental concepts of the ecclesiastical picture. After the provincial synod of Zamóść (1720) this last-named tendency became the dominating one.

In the seventeenth and eighteenth centuries the upsurge of printed books with engravings and woodcuts became an easily accessible source of inspiration for icon painters. Even today illustrated ecclesiastical books of the seventeenth and eighteenth centuries printed in Lvov or the Kiev monastery are to be found in disused churches in East Slovakia. Towards the end of the last century A. Petrov found, in Uzhgorod and Mukachevo, ecclesiastical books from Cracow (Fiol, 1491), and sixteenth-century books from Venice, Montenegro and Transylvania ('Žurnal ministerstva narodnago prosvešče-nija', CCLXXV, June 1891, St Petersburg) — a distinguished selection for disused churches. In the eighteenth century, frontier guards in the Carpathian region document a number of seizures of wagon-loads of ecclesiastical and profane books, which dealers in Kiev, Moscow and Vladimir intended to introduce into the Austro-Hungarian Empire, where the printing of Slavic books was severely restricted and all the efforts of the united and Orthodox clergy for their own printing presses remained unsuccessful. Traces of the knowledge of such books are not only to be found in forms of ornamentation — the embossed background ornamentations of the silver-based icons of Krivé (plates 31–3), for example, are reminiscent of the fine scroll framing the illustrated pages of Makarije's osmoglasnik-petoglasnik (Obod-Cetinje, 1494) and the vignette of his psalter (Cetinje, 1495) — but also in the simplified composition, the strong two-dimensionality of numerous icons and the firm outlining of the figures and the landscape.

The stages of development of the painters who remained bound to tradition are made clear by two icons depicting the Crucifixion: the first, which comes from the church in Tročany and is dated 1634 (Bratislava Catalogue, fig. 51), corresponds in its basic elements to traditional composition. The heavy cross certainly dominates the icon in a striking manner, and Christ on the cross is represented much larger in proportion to both groups of figures at his feet. Mary and the two women, who are offering solace, are united into a vital group, towards which John seems to be moving from the other side of the cross. The background is made up of the high wall of Jerusalem, over the top of which no roof or tower projects. Some details are newly added: flying angels collecting blood in goblets from the wounds in the side, hands and feet; heavy nails with wide heads which jut right out of the wounds; the wood of the cross is heavily grained; dark clouds gather over the cross and enclose the sun and the moon in the corners. The figures around the cross are very long, tall and slender; their vestments fall in a rich arrangement of folds. There is a lot of free space left between Christ on the cross and the two groups, which throws Christ into relief.

The second icon depicting the Crucifixion, which comes from Uličské Krivé (plate 37) and is dated somewhere near the beginning of the eighteenth century, shows a more concentrated representation of the theme. Christ is not dominant because he is depicted larger than the groups at the foot of the cross, but he becomes the optical centre by means of the brightly-coloured shades of his body, which stand out from the dark colours of the icon as a whole. The three women at the cross are painted in a row without any perceptible movement; the vestments hang in long parallel folds; only the lower edge of the top vestment is pointed and wavy, which helps to preserve the even rhythm of the two foremost women. The suffering of the Crucifixion is portrayed by heavy drops of blood on Christ's brow, arms, shoulders, upper body and legs. At the foot of the cross lies the ghostly skull of Adam. Behind the cross, roofs and towers with weathervanes are visible, which replace the more symbolic wall of Jerusalem. Folklorist characteristics have become stronger in this second icon, and in the background the orientation towards buildings of the painter's own milieu has increased. This is even more pronounced in representations of landscapes, for example in the icon depicting the Archangel Michael (plate 56), who stands guarding over a town and behind whom a wide landscape panorama is unfolded.

XX

A study of the development of the icon shows that with all the natural variations arising from the individuality of the artists' personality and the peculiarities of different workshops, certain new tendencies came about. The basic iconographical conception remains unaltered, but the single elements making up the picture are relaxed or varied and sometimes enriched with additional details. Drawing becomes a dominating aspect of the artistic statement of the painter — not only in the external outlines, but also in the arrangement of the folds of vestments, in facial expressions and in the design of scenic and architectonic backgrounds. The shading and tinting of colours, which were masterfully executed in sixteenth-century icons, are in the main ignored and replaced by a flat form of colouring. This two-dimensionality is also a characteristic of seventeenth-century mural paintings in the numerous wooden churches on both sides of the Carpathian mountain ridge, as well as in Maramures in the South (I. D. Stefanescu, 'Arta veche a Maramuresului', Bucharest, 1968; V. Bratulescu, 'Beserici din Maramures', Bucharest, 1941), and — even if not in all details — in Tsarist Russia (M. S. Kacer, 'Izobrazitelnoe iskusstvo Belorussii dooktjabrskogo perioda', Minsk, 1969).

Blue, from light shades to deep poster colourings, and shades of brown are favoured colours. Strong red spots of colour on the cheeks point towards facial plasticity and liveliness. The construction of figures shows a preponderant tendency towards over-lengthening, but the folklorist painters, especially in the eighteenth century, depict squat, compact figures. On many icons the main figure is slender and tall, whereas the figures depicted in the marginal scenes are more squat (the Archangel Michael from Krivé, plate 33). The inscriptions are always in two languages — Church Slavonic and Latin (the Crucifixion from Matysová, plate 35) — or latinized in details, as in the Crucifixion from Uličské Krivé (plate 37) in the INRI on the cross. Vestment ornamentation is often made up of groups of colours in circular or cruciform shapes; the same sort of ornamentation is to be found on numerous icons of the Maramures region and Moldavia, as well as on the later framed icons of Rumania. In the gilt backgrounds of the icons geometric ornamentation is replaced by large-leaved tendrils and flowers.

The craftsman's finishing also alters in many cases. The raised edges are replaced by carved beading, which appears in the upper part of the icon in the shape of an arch. In the resulting upper corners rosettes or tendrils in relief are indented, or an ornament or putto is painted in. The wide edges

retain as ornamentation symmetrical, circular, cylindrical or quadrilateral bosses, which are either golden or take on the basic colour of the frame. On some icons an ornament is painted around these bosses in relief, which is reminiscent in shape of forged Gothic and Renaissance door-knobs. In the second half of the seventeenth century, and even more so in the eighteenth, a large number of icons were based on the architectonic shape of Occidental altars. Coloured columns with tendrils and grapes, adorned with carved capitals and gables, surround the inner section. This form of surround was undoubtedly stimulated by the custom of placing an icon on the altar, the meaning of which would be emphasised by such an adornment; the golden frame would have a festive effect in the dark space.

In the seventeenth century the secular portrait became the standard for a depiction of the Saints, at least for the painters who had shown themselves to be open-minded from the onset to Occidental ecclesiastical painting. Faces are natural and lively, and the painter also pays due respect to the splendour of the episcopal robes. A typical example of this type of painting is the icon of St Nicholas from the church in Ladomírová (plate 48), which dates from the second half of the seventeenth century. The realistically detailed raiment, inner section and background, the sense of the decorative, present even in the detail of the Gospel-book, all this is quite strictly related to the secular portrait. As far as scenic representations are concerned, the development in the eighteenth century led to emotional devotional pictures such as the Adoration of the Child from the Iconostasis in Príkra (plate 60). The insertion of landscapes and clothing taken from the environment of the painter, which began in the seventeenth century, was now taken even further.

In the eighteenth and nineteenth centuries in the Slovak Carpathian region, icon painters were mainly artists who had studied at art schools or academies and had completed their instruction with master craftsmen; they consciously rejected the traditional forms of icon painting. Traces of almost pure Occidental painting have been left by Andrej and Mikuláš Gajecký in Lukov-Venecia (1736), and Jedlinka (1744), Toroňský in Rovné (1785), in the nineteenth century Jan Rombauer in Cernina (1840), Michael Mankovič in Čabalovce (1814), Ňagov (1831) and Fulianka (1831), Jozef Mirejowský in Nižný Mirošov (1801), Peter Fenczik in Kalná Roztoka (1866), Juliusz Mihalyi and his brother Anton in Michajlov (1875) and Ulič (1879) and members of the Bogdaňski family in numerous churches, of which single

examples cannot be mentioned here (see Maria Przeździecka, Dzieje rodu Bogdańskich, malarzy cerkiewnych po obu stronach Karpat, in Vedecký sborník múzea ukrajinskej kultúry vo Svidníku, I, 1965, pp. 107–27). That such Occidental pictures were used as icons probably stemmed from the wish of the clergy and the communions of this religious minority to reach a state of equality with the Western churches, which is similar to the present-day wish for stone churches, as the delightful old wooden churches are regarded as a poor relic of times past.

So ends a rich variant of Orthodox icon painting, the development of which could only be discussed in broad outlines here, and its adaptation to the art of the Occidental churches of the same region; the relics of earlier centuries give an eloquent testimonial of independent artistic creation, which was active for centuries and was able to establish a characteristic form.

In conclusion, many institutions and individuals must be thanked for their constant and friendly assistance and help and for their permission to reproduce the works: The Directors of the National Gallery in Prague, Dr Jan Krofta and his successor Prof. Dr Jiří Kotalík; Dr Jaromír Homolka and Dr Karel Otavský, who assisted with the work in the depository of Křivoklát Castle. The author also thanks Prof. Dr Vladimír Fiala of Prague, Dr Karol Vaculík, Director of the Slovak National Gallery, Dr Ján Mihal, Director of the Museum for the Šariš District in Bardejov, and his colleagues Miss Darina Kendrová, Tibor Weiss and Mikuláš Lowacký, Ján Čabiňák, Director of the Museum of Ukrainian Culture in Svidník, for their valuable suggestions. Mr P. Fodor, restorer in Bratislava, made it possible to work on the Komárno icons in his restoration workshops. Dr Bartová, Directress of the Danube Museum in Komárno, gave her permission for the reproductions. Dr Josef Myslivec, of Prague, an expert on icon painting, encouraged me in my work, enabled me to consult out-of-print literature, and gave me much valuable advice. Alexander Frický from the State Institute for the Care of Monuments in Bratislava, who has played an important part in the preservation of icons from East Slovakia, published parts of the material in a short film and in various essays, and organised an international conference in Bardejovské Kúpele in August 1968, which was unfortunately cancelled, and encouraged this book in every conceivable way. Nor must the priests and sacristans of the East Slovak churches be forgotten, who always opened their churches gladly and patiently, and afforded the author time to study the works at leisure.

Special thanks are due to my colleague at the National Museum in Cracow, Miss Janina Klosińska, the greatest icon expert in the Polish Carpathian foothills, who gave me the benefit of her wide knowledge and obtained important references to the paleography and other matters of detail from members of Jagiello University. Thanks are also due to Dr Corina Nicolescu, of the Museum of the Socialist Republic of Rumania in Bucharest, for iconographic and hagiographic information.

THE PLATES

1

THE ENTRY INTO JERUSALEM

Greek, second half of the 16th century.

Wood, 49 × 34 cm.

NATIONAL GALLERY, PRAGUE; formerly in the Collection of the Kondakov
Institute, acquired from the Soldatenkov Collection.

Inv. No. DO – 3389

Rounded off in the form of an arcade in the upper part, this icon is mounted in
a heavy gilt frame. In the centre of the golden background a huge tree rises up.
In the tree-top two children are snapping off twigs, while a third one is climbing
up the slender trunk. On the left, a rugged, craggy landscape towers up, which
spreads out into two mountain peaks. On the right, the crenellated wall of
Jerusalem terminates by the tree. Within the city, the sharp gables of the
houses, round cupolas and barrel-shaped vaults of roofs are visible. Above the
narrow, high city-gate a niche with the bust of a man in profile has been in-
serted in the façade of the wall. Men and women are walking through the
gate to greet the arrival of the King. A boy holds a twig in his hand, ready to
throw it on the ground, where beneath the hooves of the ass, there already lies
a garment. Christ is sitting on a white ass and is turned towards Peter and the
other disciples. His right hand is raised in blessing, his left hand holds a scroll.
He alone is painted with a halo. Children play in the foreground unperturbed
by the event. Two of them are fighting, another looks up and stretches his
left arm out, the fourth pulls his robe over his head. In spite of its genre
motif, this icon dates from the second half of the 16th century, rather than from
as late as the 17th century.

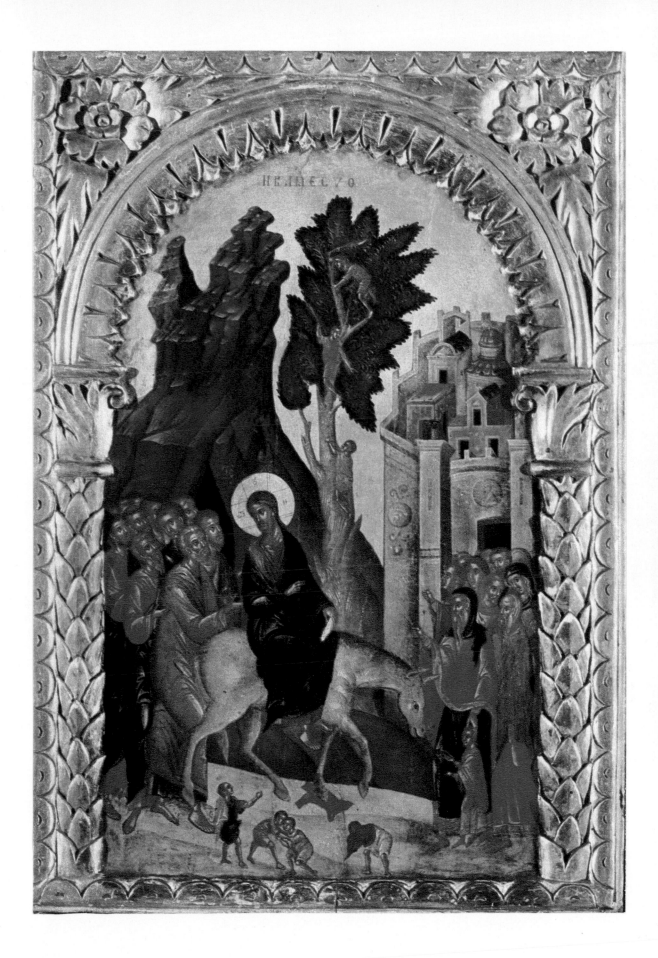

2

THE VIRGIN GLYCOPHILOUSA,

Greek, end of the 16th century.

Wood, 82 × 65 cm.

NATIONAL GALLERY, PRAGUE; formerly in the Collection of the Kondakov
Institute, acquired from the Soldatenkov Collection.

Inv. No. 3390.

This icon of the gentle Mother of God has a deepened inner middleground,
the heightened edge of which is bordered by a red stripe. The portrait is half-
length, with Our Lady holding the young Jesus with both hands and drawing
him to her breast. The child's cheek is pressed close to its mother. The Virgin
is wearing a dark-blue robe with a gold border and beneath it a dark wine-red
kerchief. An embroidered golden star is visible on her veil and right shoulder.
Jesus is wearing a blue undergarment with a gold trimming and red clavi. His
yellowish-brown top robe is stripped down to the waist. His left hand is
clutching his mother's maphorion, his right hand hangs down holding an unrolled
scroll with the text: 'The Spirit of the Lord is upon me, because he hath anoin-
ted me...' (Luke 4.18). The haloes show a finely executed decoration with
six-petalled flowers and creepers. In the upper corners of the picture are, to
the left, the Archangel Michael, and to the right, the Archangel Gabriel, in
half-length portraits. This icon may be the exact copy of a Greek model by
a Russian painter, as the technical treatment shows the insertion of two wooden
bars on the back of the panel, which is unusual for the Greeks.

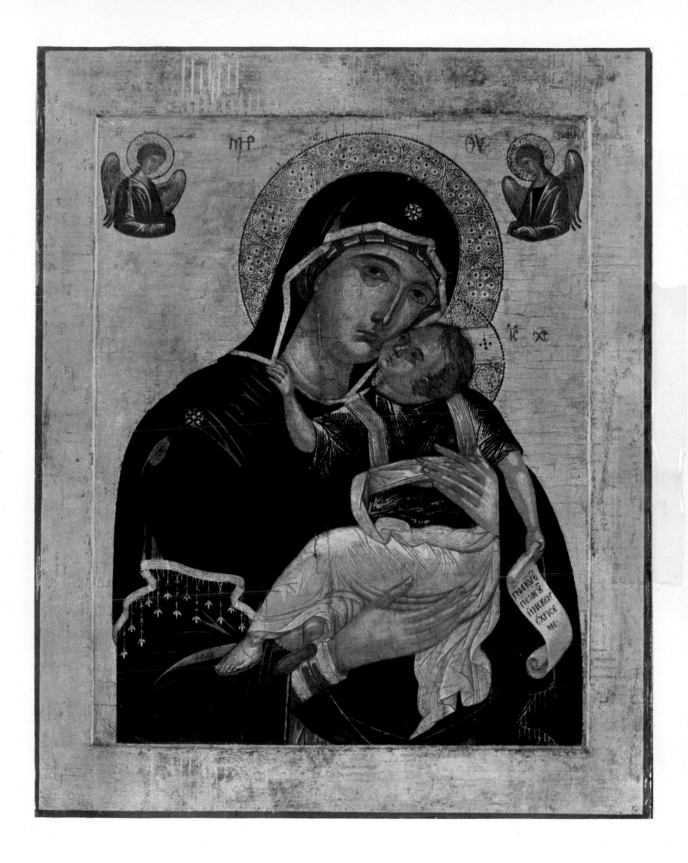

3

THE RAISING OF LAZARUS

Greek, second half of the 17th century.

Wood, 35.6 × 27.6 cm.

DANUBE MUSEUM, KOMÁRNO.

Inv. No. 56/56/203/5

This icon with a golden background is mounted in a simple frame. This frame consists of two strips: the inner is golden with a creeper painted black with red flowers, the outer is red and has a simple black creeper. The raising of Lazarus from the dead is treated with a determined iconography. Behind Christ, who is followed by the disciples, the buildings of a town appear and the stylised, rocky landscape crowned by a large tree towers up behind the sarcophagus containing Lazarus. At the edge of these rocks, and from the distance, a group of priests and citizens approaches, eager to witness the event. The sarcophagus is open, the lid lies nearby. Lazarus is standing at the foot of the sarcophagus, still wrapped in the white bandages in which the dead are dressed. A young man beside him is busy untying the bandages. In front of the sarcophagus Lazarus's two sisters are thanking the Lord, one is prostrate at his feet, the other kneeling before him. Their clothes have a pattern of flowers, made out of gold dots. Christ is striding with long steps towards the group about Lazarus, his right hand outstretched and pointing. He has a scroll in his left hand. The rich decorativeness of his robes is unusual: his dark-red undergarment has flowers made of groups of dots, his bright blue cloak is embroidered with various sorts of creepers and flowers in gold. The artist has signed the picture on the facing side of the lid of the sarcophagus: 'The hand of Georgio, the Painter'. The heightened dramatic quality and the determined interpretation of the theme are typical of Greek — and Serbian — 17th-century icons.

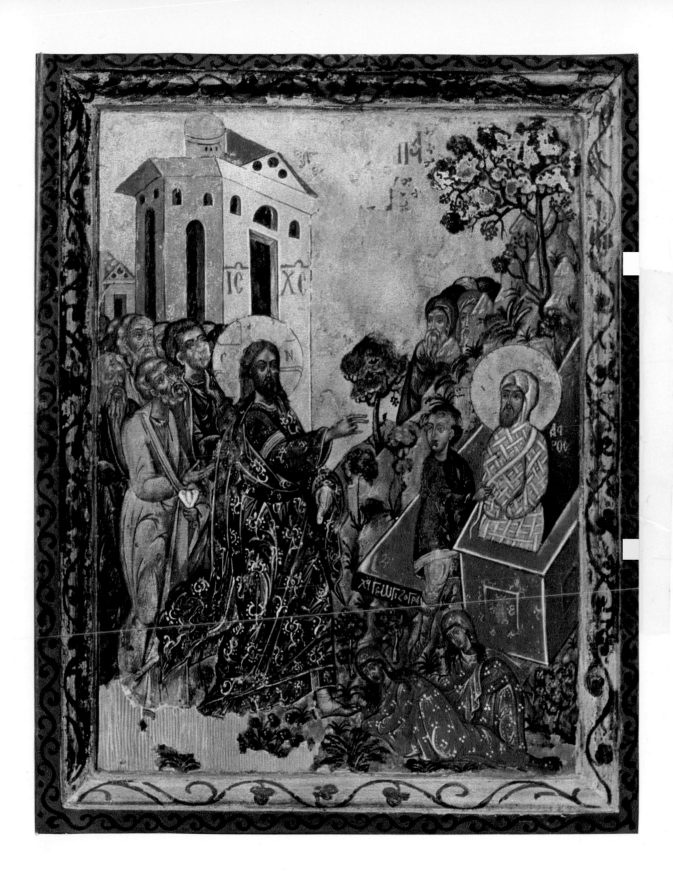

4

THE RESURRECTION (DESCENT INTO HELL)

Russian, beginning of the 16th century.

Wood, 24 × 16.5 cm.

NATIONAL GALLERY, PRAGUE; acquired from a private collection in Prague.
Inv. No. DO-2725.

This icon is only a fragment sawn from a larger complex; it is very warped on the surface. It belongs to those portrayals of the Resurrection and the Descent into Hell which prefer an archaic formal expression and symmetrical composition. Before a golden aureola with a wide, blue-black edge and pierced by rays of light, Christ is standing at the threshold of the Underworld; with both his hands he grips the wrists of Adam and Eve and pulls them out of their graves. Behind Adam are King David and Solomon; behind Eve are two other Old Testament figures, which do not allow definite identification. In the golden ground with the red inscription two grey-green terraces of rocks appear, which spread out into three circular peaks. This icon was probably painted at the beginning of the 16th century. In it we find a mixture of Muscovite stylistic elements and the colourfulness of Novgorod.

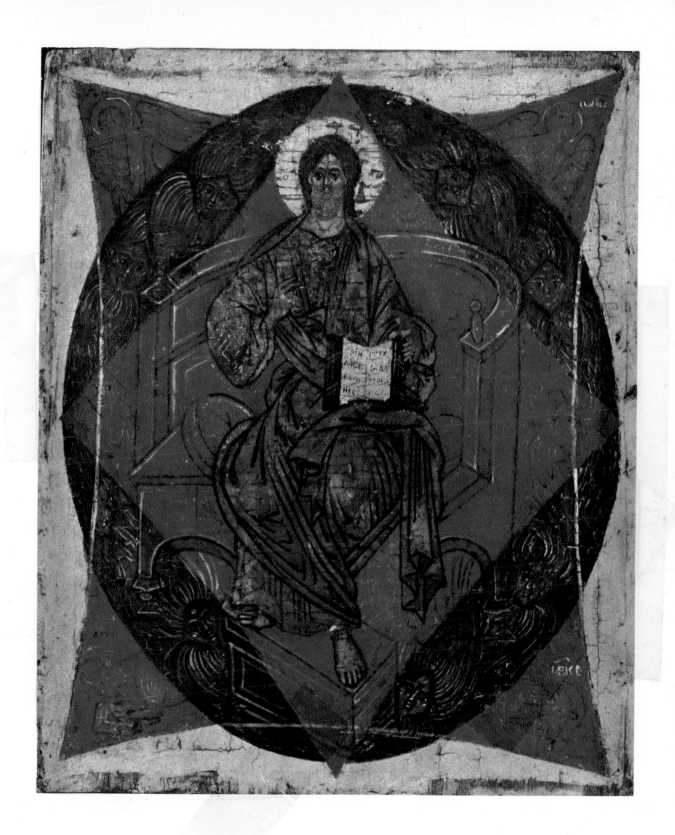

6

ST PAUL OBNORSKIJ

Muscovite School, end of the 16th century.

Canvas on wood, 23.5 × 17 cm.

NATIONAL GALLERY, PRAGUE.

Inv. No. DO–5080.

St Paul Obnorskij (d.1429) was a pupil of St Sergij of Radonezh. He retreated
to the Trans-Volga region where he lived for three years as an ascetic in the
hollow of a tree. In about 1381 he founded, on the banks of the Obnora (a small
river), the Monastery of the Trinity (Troitskij-Obnorskij Monastery). He is
said to have died at the great age of 112. The Church Congress in Moscow of
1547 gave him a general vote of respect.
This icon is mounted in a gilded raised frame with a broad red stripe. St Paul
Obnorskij is portrayed in a humble posture. He stands turned towards the
right and stretches his arms in prayer towards the circular piece of sky in the
upper right corner. The cast of the drapery and the resplendence show paral-
lels to other portraits of saints of the Muscovite School of the mid- and late
16th century.

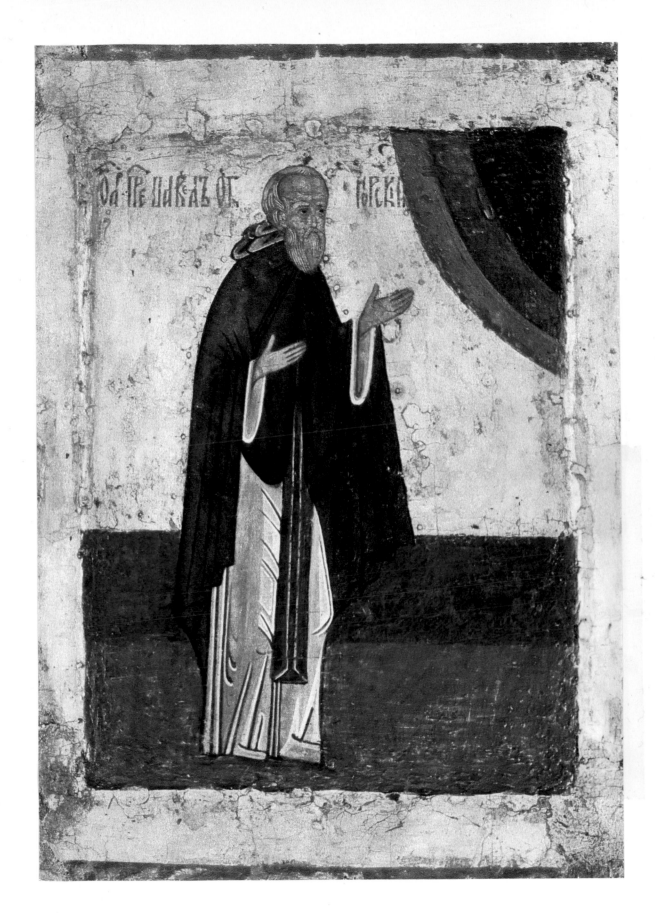

7

THE DOUBTING THOMAS

Russian, 16th century.

Wood, 47.5 × 35 cm.

NATIONAL GALLERY, PRAGUE; formerly in the Collection of the Kondakov Institute.

Inv. No. DO-3400.

The deepened middleground of this icon is surrounded by a wide gilded border with red outer stripes above and below. In the focal point of the picture, Christ is standing on a pedestal in front of a building, and is dressed in a red garment under a green cloak. In his left hand is a scroll, while with his right hand he gathers up his robes and shows the wound in his side. The young Apostle Thomas walks towards him, with bowed head, and touches the wound with his finger. The other disciples are in two groups beside Christ and Thomas. The architecture consists of a greenish wall, simply decorated, and a yellowish house with a green-black roof. Behind the wall three tree tops bend towards the centre of the picture, and a red vellum floats over the wall and the house top. This iconography of the doubting of Thomas is already in evidence, with very minimal deviations, in a Novgorod icon painted at the end of the 15th, or the beginning of the 16th century (V. N. Lazarev, Iskusstvo Novgoroda, Moscow 1947, plate 122), in the Novgorod Museum, and also in a second icon, which is attributed, with reservations, to the painter Dionisij and is in the Tretyakov Gallery in Moscow. As this icon is among the works which show a mixture of Muscovite and Novgorod elements, it is probable that the artist was active in the second half of the 16th century.

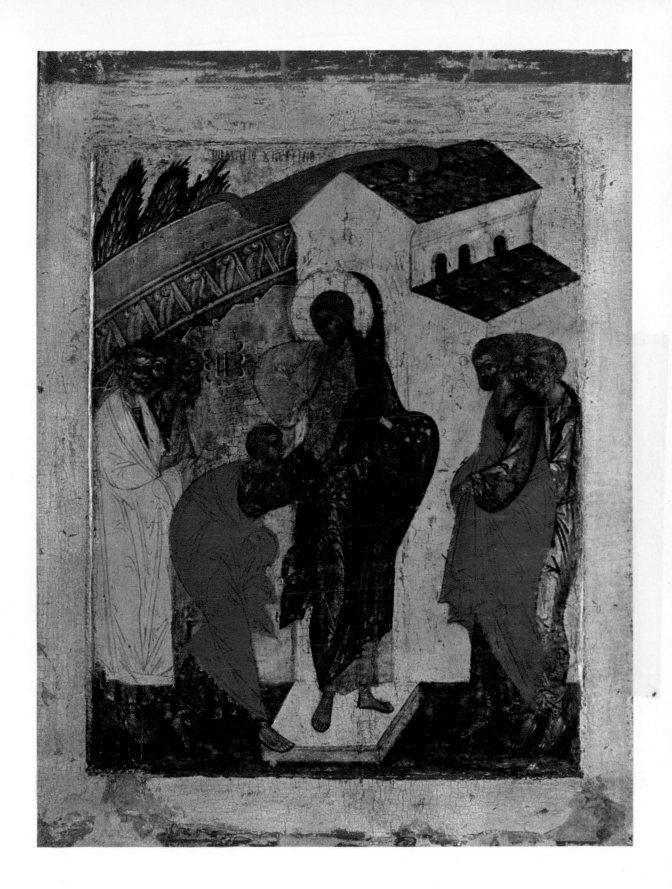

THE ANNUNCIATION

Russian, 16th century.

Wood, 47.5 × 35 cm.

NATIONAL GALLERY, PRAGUE; formerly in the Collection of the Kondakov Institute.

Inv. No. DO-3399.

This icon belongs to a group of festival pictures, of which The Doubting Thomas (Plate 7) and The Holy Women at the Sepulchre are to be found in the National Gallery, Prague. For this reason the treatment of the raised border is identical to the preceding plate. The intense colour of the two other icons is obviously not matched in this one. The graphic structure of the architectural background is the dominant feature. A pale pink house, to the left, and a whitish-grey tower, to the right, are linked by a red vellum which sets a strong colour accent. The wall between the two houses is simply decorated. A broad blue-green ray of light emanates from the centre of the upper edge of the picture from a narrow circular segment, which encloses a medallion with the dove of the Holy Ghost and is then taken further towards the Holy Virgin in three sharp points. Mary is sitting on a stool-shaped throne with a red and a green cushion. Her left hand is raised in greeting. The red thread on the cotton-reel in her right hand runs over her raised left hand to the suspended spindle. The Archangel Gabriel has his right hand outstretched in greeting and as a sign of the annunciation which he is making. Even the staff in his left hand is lowered in greeting. Gabriel's left wing is raised sharply upwards. The dynamic force of the angel is contrasted with the static calm of Mary. This icon again shows a mixture of Muscovite and Novgorod elements.

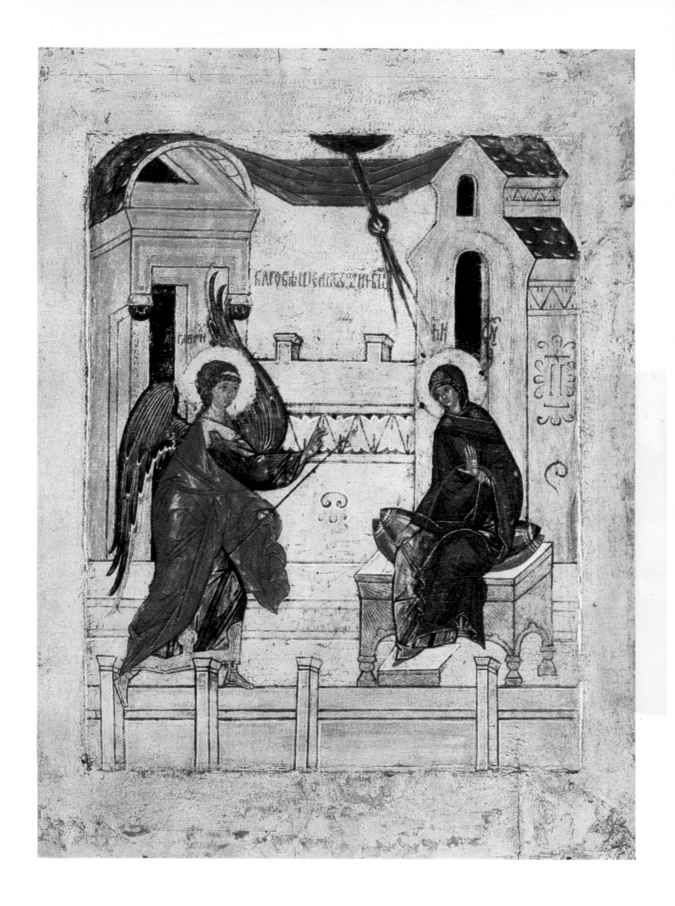

ST PROKOPIJ OF USTYUG AND ST VARLAAM KHUTYNSKIJ

Russian, in the northern manner, end of the 16th, beginning of the 17th century.
NATIONAL GALLERY, PRAGUE; formerly in the Collection of the Kondakov
Institute, acquired from the Soldatenkov Collection.
Inv. No. DO–3344

St Prokopij of Ustyug (d. 1302) is one of the 'Fools in Christ'. According to the legend, he was a rich merchant of German origin, who chose for himself the life of a Fool in Christ and wandered eastwards to the region around Ustyug. There he was also respected by the inhabitants as a weather prophet: for he carried with him a poker and when he held it with the handle upwards it was a sign of good weather and a good harvest. St Varlaam Khutynskij (d. 6.11. 1192), the son of a wealthy Novgorod family, felt an early call to the monastic life and retreated to the Lissickij Monastery in Novgorod, where he lived in a hermit's retreat called Khutyn. The increasing number of god-fearing people led to the founding of the Monastery of the Transfiguration.
The two saints are portrayed in this icon: Prokopij with a poker and Varlaam with a staff. They are beside a large round medallion of Christ Emmanuel. Their right hands are stretched upwards in prayer. Varlaam, who is usually depicted in iconography with a hood drawn over his face, is bareheaded here. The red inscription calls the two saints the Miracle-workers of Ustyug and Khutyn respectively. The artist probably worked in Northern Russia, possibly in the region of Ustyug, and the icon dates from the end of the 16th or the beginning of the 17th century.

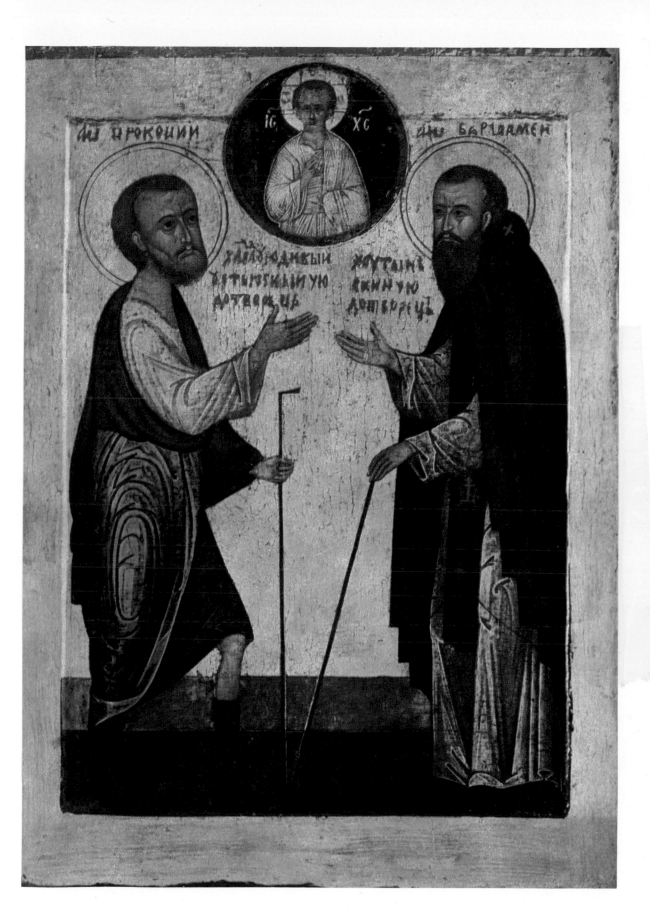

10

ST JOHN THE EVANGELIST AND A HOLY WARRIOR

Russian, end of the 16th, beginning of the 17th century.

Wood, 46.4 × 34.5 cm.

NATIONAL GALLERY, PRAGUE.

Inv. No. 0–1562.

The lower part of the deepened inner middleground of this icon forms a greenish base on which two saints are standing. The aged figure to the left is St John the Evangelist. Over his pale reddish robe with a band (clavus) he wears a green cloak which is the same green as the ground. John is barefoot. His right hand is raised in blessing and in his concealed left hand he holds an open Gospel-book with a variant of the text: 'In the beginning was the Word and the Word was with God.' (John 1.1.) Beside him stands a young warrior dressed in decorative gold armour over a brown doublet and a red undergarment. A whitish-grey cloak is slung across his left shoulder. In his right hand he holds a sword pointing over his right shoulder and in his left hand, the sheath. The round-faced youthful warrior could be St Demetrius of Salonika. The fact that the heads are particularly small in proportion to the elongated bodies is very stiriking in this icon. The characteristics of elongating the figures and generally neglecting natural proportions recur in a series of icons at the turn of the 16th century. It is probable that the artist came from a workshop in the region of Moscow.

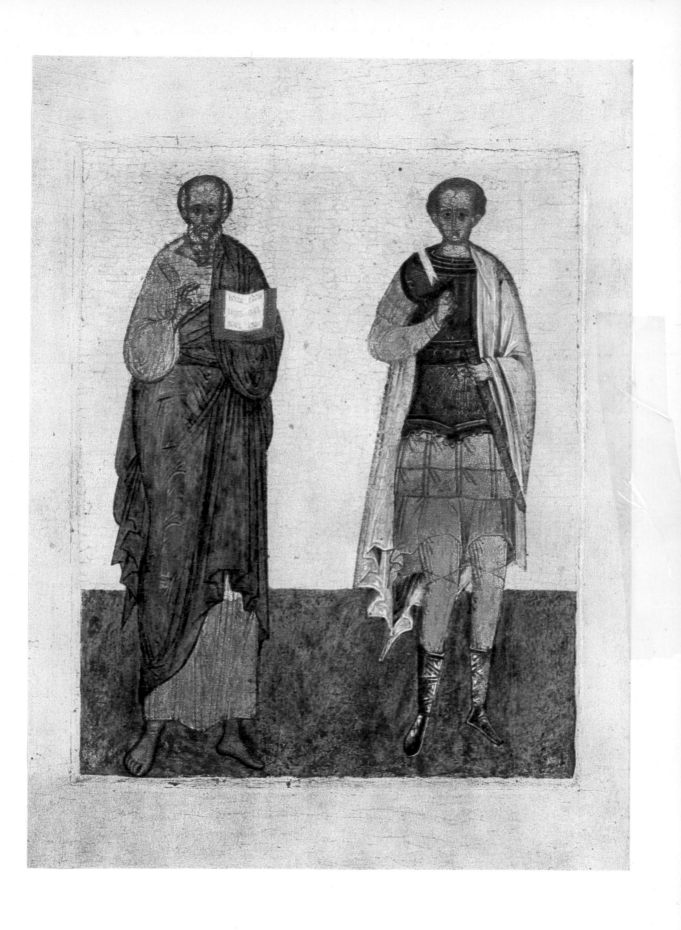

11

THE BIRTH OF THE VIRGIN

Muscovite School, mid-17th century.

Canvas on wood, 30.5 × 27 cm.

NATIONAL GALLERY, PRAGUE; formerly in the Collection of the Kondakov
Institute, acquired from the Soldatenkov Collection.

Inv. No. DO – 3350.

The artist has written the title of this icon at the top of the picture on the
wide border which is surrounded by a thin red stripe: The birth of the most Holy
Virgin Mary. Unlike the archaic language of old icons, he prefers a broadly
devised account and links a series of individual scenes to an ensemble. In the
upper part of the picture he portrays the prayer of Joachim who has fled into
the wilderness (left) and Anne (right). Angels bring them the message from
God, that they are to go to the Golden Gate in Jerusalem. This meeting at the
Golden Gate which, in the embrace of Joachim and Anne, symbolises the
conception of St Anne, is painted in the centre of the upper part. The larger
central part consists of two scenes. To the left, the birth of Mary is portrayed
by Anne who is resting on the bed, served with food and drink by serving-girls
who fan her to keep her cool. Two other serving-girls are sitting by the bed, one
filling a bath-tub with water while the other, with the newborn child in her
lap, tests the temperature of the water with her hand. To the right, Joachim
and Anne sit on a throne adorned with creepers and caress their child. The
marginal border at the bottom of the picture consists of scenes from everyday
life, a feature which is in evidence in a similar way on a Byzantine icon of the
Annunciation dating from c. 1200, in the monastery on Mount Sinai. On a thin
strip of meadow with tall grass stands a two-tiered well; two birds drink from
the lower basin, while four more hop about the meadow. Borders such as this
with similar themes occur on Russian icons, as for example in a picture of the
Annunciation dating from the late 16th century in the Russian Museum, Lenin-
grad, or in the 17th-century Zosiam and Savatij in the Recklinghausen Icon
Museum.

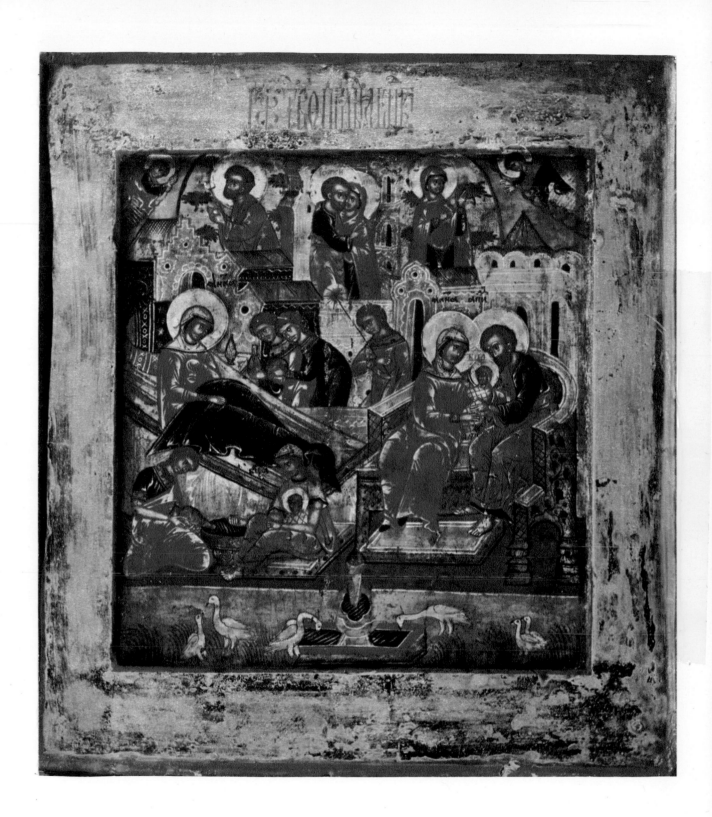

12

ST JOHN AND ST PROCHORUS

Muscovite School, beginning of the 17th century.

Wood, 31 × 25 cm.

NATIONAL GALLERY, PRAGUE; formerly in the Collection of the Kondakov Institute, acquired from the Soldatenkov Collection.

Inv. No. DO – 3345

The wide border of this icon is painted olive-green and set off by an outer red stripe. On the upper edge the artist has written the title of the icon in ornate lettering: 'The Holy Apostle and Evangelist John, the Theologian'. The landscape background consists of rugged crags covered with red flowering bushes. Behind the strange rock formations parts of a house with gold-barred windows can be seen. A circular segment—a symbol of the sky—can be seen in the left upper corner. In it are stars and golden rays of light. Three long, pointed, white rays shine down on John out of an umbel-shaped group of rays. The Evangelist's head is sunk on to his left shoulder and his ear is turned to hear the divine inspiration. With his right hand he points to the Gospel-book held in his left arm. This book has red page-edges and the binding is decorated with golden clasps. Bent over a table, the young Prochorus sits beside John and writes the beginning of the Gospel according to St John on a sheet of paper. In the rocks behind Prochorus gapes the dark gloom of a cave. The painter of this icon shows a sure hand in the layout of the detail, but tends to manneristic exaggeration. The forceful treatment of the detail, the feeling for calligraphy and inclination towards certain mannerisms, all go to hallmark Russian icons from the area around Moscow and also from the so-called Stroganov School at the beginning of the 17th century.

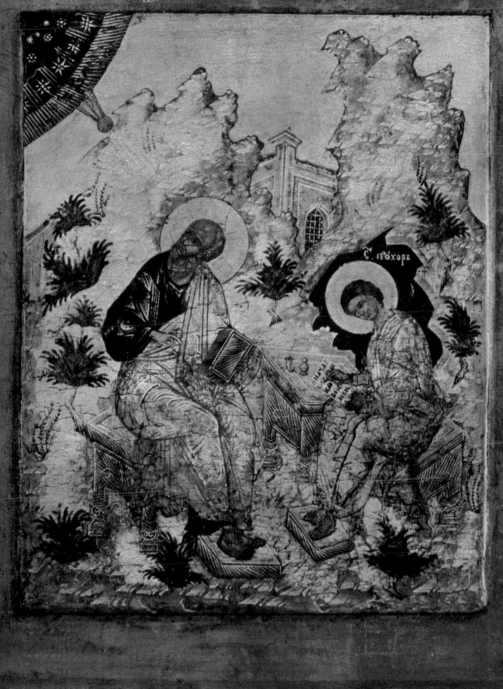

13

THE NATIVITY

Muscovite School, mid-17th century,

Wood, 38 × 31 cm.

NATIONAL GALLERY, PRAGUE; formerly in the Collection of the Kondakov Institute, acquired from the Soldatenkov Collection.

Inv. No. DO – 3354.

The raised wide outer border of this icon is yellowish and offset by red on the outside. In the top centre is the title of the icon: 'The Nativity of Our Lord Jesus Christ', written in ornate lettering. In smaller, neat writing in the upper border and down the sides are textual explanations of the individual scenes in the picture, giving an account beginning with the Journey of the Magi and ending with the Flight into Egypt. The Magi cycle (1a–d) shows their journey, guided by the star, the adoration of the Child (b), their awakening and warning against Herod by the angel (c) and their riding away (d). The Nativity of Christ (2a–d) in the upper central part of the picture shows an angel arresting the star over the cave (a), the cave with the Virgin, the Child, the ox and ass, the Child being washed and angels adoring him (b), Joseph with the shepherd (tempter?) (c), and shepherds gazing at the star (d). The angel awakes Joseph (3a) and urges him to flee to Egypt (3b). Herod and his counsellors (4a) are painted at the Massacre of the Innocents (4b), to which the group of women in mourning (4c) belong, together with John and Elizabeth, who are hiding in a cave from the murderous soldiers (4d). The killing of Zacharias on the altar concludes the account (5). The profusion of the individual scenes is artistically strung together. The miniature-like painting and the meticulousness with which the painter made use of the decorative possibilities are hallmarks of the School of painting in Moscow in the mid-17th century.

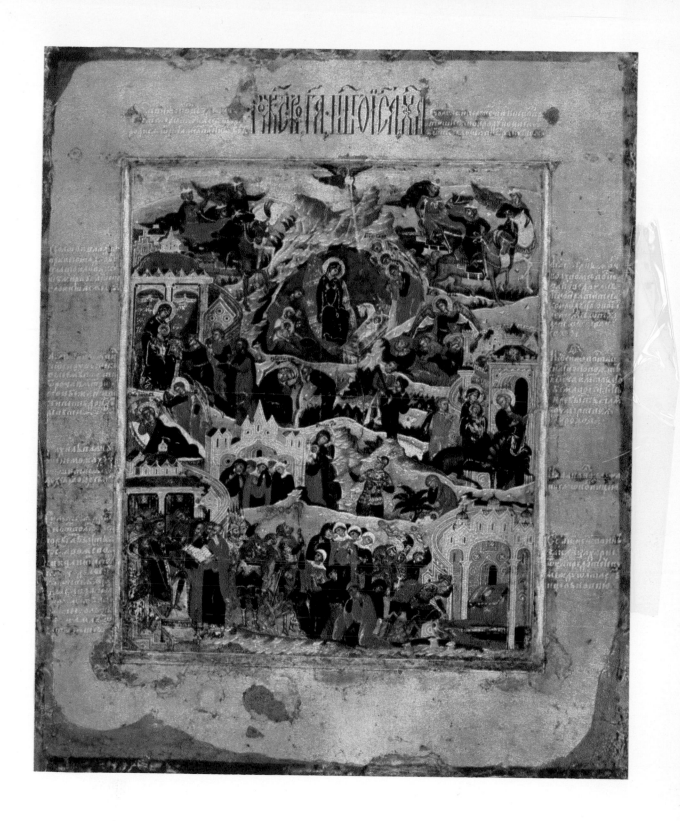

14

THE DORMITION OF THE VIRGIN

Ruthenian, end of the 16th century.

Wood, 123 × 92 cm.

NATIONAL GALLERY, PRAGUE; acquired from a private collection in Prague.
Inv. No. O – 8318.

This large icon, bordered by a wide red and gold strip, portrays the theme of traditional iconography. The outer strip of the blackish-green mandorla around Christ is filled with angels and cherubim. In his left arm Christ holds the soul of his mother. The Apostles are grouped around the Virgin's death-bed in such a way that four of them are mourning at the head of the bed and eight at the foot. In the background two bishops and mourning women from the city of Jerusalem join the groups of the Apostles; the buildings of Jerusalem complete the scene. In the foreground the castigation of the transgressor Jephonias is portrayed, with an angel striking off his hands with a sword. In the upper edge of the picture the circular segment of sky appears, with a book lying open in it. The strong colour of the robes and buildings is striking. The faces are characterised, which is as foreign to the Novgorod and Pskov regions as are the already-mentioned bold colours. The three-cornered pointed hard folds recur on some icons from the Carpathian region, for example, in the figures of the Last Judgment in the Church of Lukov-Venecia (Plate 23). Likewise the unusual writing of the festival, *V'SPENIE*, instead of *USPENIE* is possible in the Ruthenian region and is thought to have parallels in textual transcripts of illiterate scribes of the time. Iconographic, stylistic and paleographic criteria speak for this icon's connection with the art of the Carpathian region.

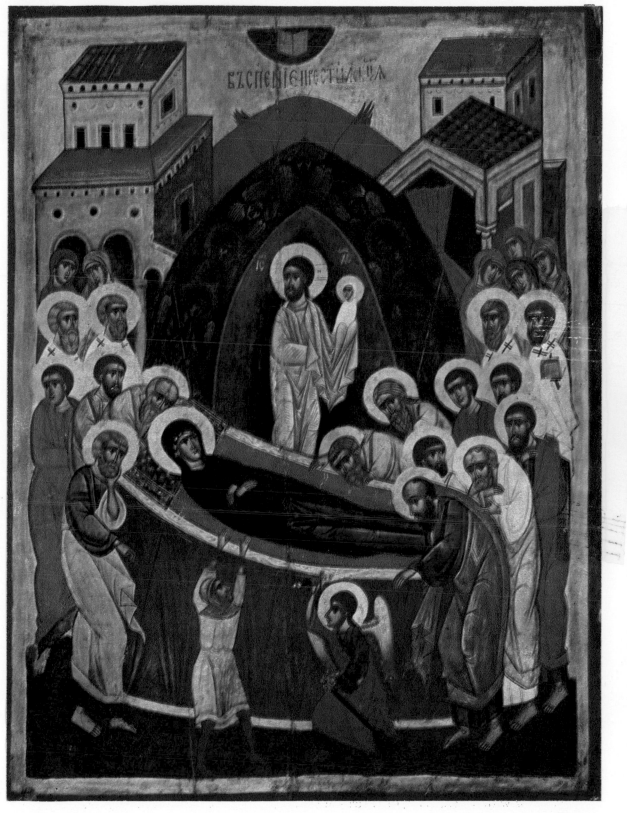

15

THE LAST JUDGMENT

From the Church in Krajná Bystra.

Detail.

Mid-16th century.

Wood, 110 × 183 cm.

MUSEUM OF UKRAINIAN CULTURE. SVIDNÍK.

Inv. No. 1141/60.

The detail of this picture from the very fragmentary icon of the Last Judgment shows the Chorus of the Redeemed, approaching the Hetimasia, the throne that has been prepared for the return of the Lord. On this throne, which is like a chest, lies a greenish-grey cloth with rich drapery, and on the cloth the dove is portrayed on a pearl-embroidered cushion, as a symbol of the Holy Ghost. Adam and Eve, the Mother and Father of Mankind, kneel at each side of the throne. Behind Eve one can make out the fragments of the figure of a Jew among the ranks of the damned. In the front of this group of the damned but isolated from them, strides Moses, with his right hand pointing at the rising Christ. Three groups of the chosen ones follow Adam. Leading them are the Hierarchs and Fathers of the Church, followed by the prophets and martyrs. Walking along, on the left of the picture behind the martyrs, is Paul the Apostle, who, like Moses on the opposite side, points upwards to Christ with his left hand and holds up an unrolled scroll in his right hand. Among these groups and forming a second rank are the holy monks, and behind them the holy nuns and female martyrs. The bodies of these three groups are partly hidden by a layered wall surrounding the Garden of Eden in which one can see Jacob, Abraham, Isaac, and beside these three patriarchs, the Virgin between the Archangels, Michael and Gabriel. (The detail illustrated here does not show these figures.) Beneath the throne God's hand is painted, with the souls of the righteous raised up in the arch of his palm. A pair of scales hangs from his forefinger which is used for weighing good and evil deeds. A fiery river also issues forth from the throne which broadens out in the lower right corner of the picture as it nears the Lower Regions. The raising of the dead is portrayed beside this infernal river, and an elephant is represented here as one of the animals which have delivered up the people they had killed. On the left of the picture is a thin strip with white-edged window openings in which dark-brown devils are portrayed. They have been keeping the accounts of the sins of those who have passed away—fornication, sodomy, sorcery, selfishness, heresy, pride—to name just a few of the vices listed. A white-robed angel with red wings flies in front of each window with a dead soul, to check the extent of the guilt and to save the soul. The construction of the figures and the expressive portrayal of the faces are still linked to the Classical traditions of icon painting. In the trees of Paradise one can see, in a calculated form, the connection with ornamental transposition, which one also finds in other icons of this kind.

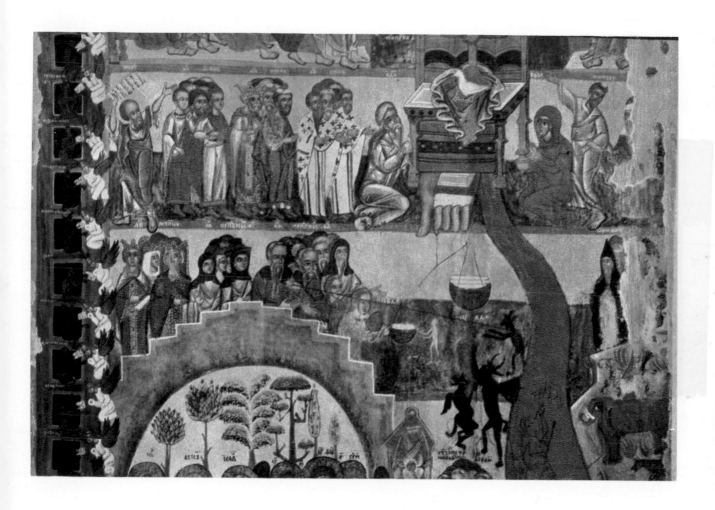

16

CHRIST PANTOCRATOR

Second half of the 16th century.

Wood, 137 × 89 cm.

WOODEN CHURCH OF THE ARCHANGEL MICHAEL, ULIČSKÉ KRIVÉ.

The enthroned Christ Pantocrator is a frequently treated theme in the art of the Eastern Church. The iconography selected here is particularly frequent in Russia, and rarely used in Byzantine regions. The portrait of Christ is surrounded by a colourful bright background, formed by two concave red squares set at right-angles, the foremost of which is, in addition, surrounded by a blue mandorla. Cherubim and seraphim are portrayed in this mandorla, which—like the throne of Christ—is drawn merely with white strokes. In the foremost corners of the foot-rest two winged wheels are painted; they symbolise the angelic hierarchy of the thrones. Long rays of light emanate from Christ's face into the four corners of the picture. The red points of the square at the back show the symbols of the four Evangelists, namely in the upper left, Matthew; the upper right, John; the lower left, Mark, and the lower right, Luke. Christ Pantocrator is wearing yellow robes trimmed with gold. His right hand is raised in a gesture of blessing. His left hand holds the cover of the Gospel-book between the open clasps, resting it on his left thigh. The text is a variant of John 7.24; 'Judge not according to the appearance, but judge righteous judgment'. The raised border of this large icon is decorated with a carefully executed design of large-leaved creepers.

The soft formation of the face, the calculated figure construction and the harmonious flow in the folds of his robes puts this icon in the group of works which are still very near the Classical period.

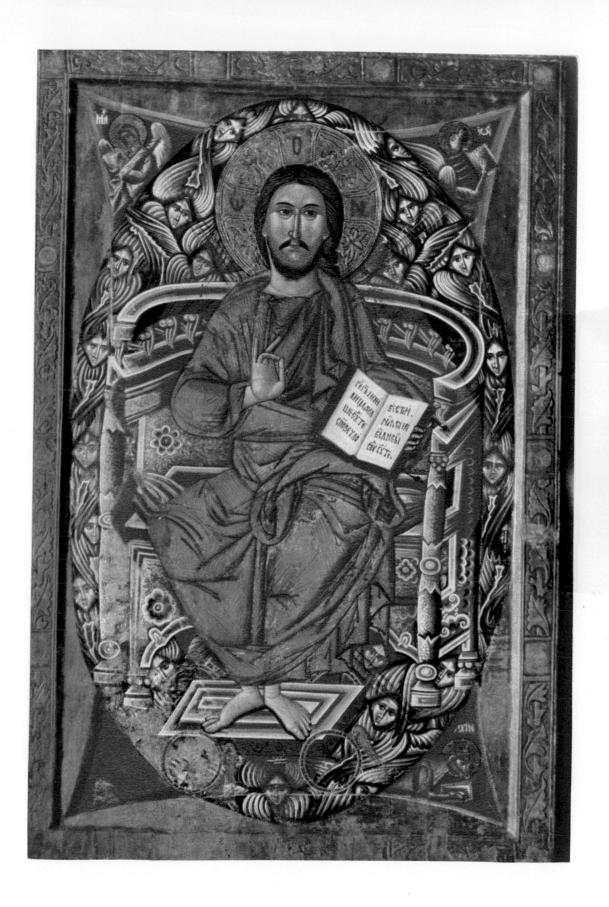

17

GROUP OF SAINTS FROM DEESIS

From the wooden Church in Rovné.

Second half of the 16th century.

Wood, 107 × 160 cm.

MUSEUM FOR THE ŠARIŠ DISTRICT, BARDEJOV.

Inv. No. 1233b.

This panel forms part of the old Deesis series in the Iconostasis of the wooden Church in Rovné, which no longer stands. The icons of the Deesis series were overpainted at the close of the 18th century with a row of Apostles. It was only two years ago that the original figures of the Deesis were revealed through restoration work. Our panel joins the central group in the north (Christ between the Virgin Mary and John the Baptist), namely with Mary standing in front of the Archangel Gabriel. The group shows, from left to right, John Chrysostom, Luke the Apostle and Evangelist, Peter the Apostle, and the Archangel Gabriel. The flow in the movement and rhythm of this picture is varied in contrast with Deesis groups of Russian and Greek Iconostases, in which the figures accentuate an even walking-rhythm, thereby creating an effect of solemn calm and symmetry—when they are portrayed in a standing position. Gabriel and Peter have their left feet forward but whereas Peter is leaning forward, Gabriel's body seems to be leaning back. Luke is striding along with his right foot forward, while John Chrysostom is biding his time motionless.

In his left hand Gabriel holds a white medallion with a red cross and the letters IC XC (i.e., Jesus Christ) on his breast and in his right hand a long staff adorned by a cross. Peter has a scroll in his left hand as an attribute. Luke holds a Gospel-book with ornate clasps in his left hand, the book resting on his forearm. John Chrysostom holds a book with red page-edges and black clasps. The background of the icon is gold, only the lower part has a mottled greenish-black strip of ground.

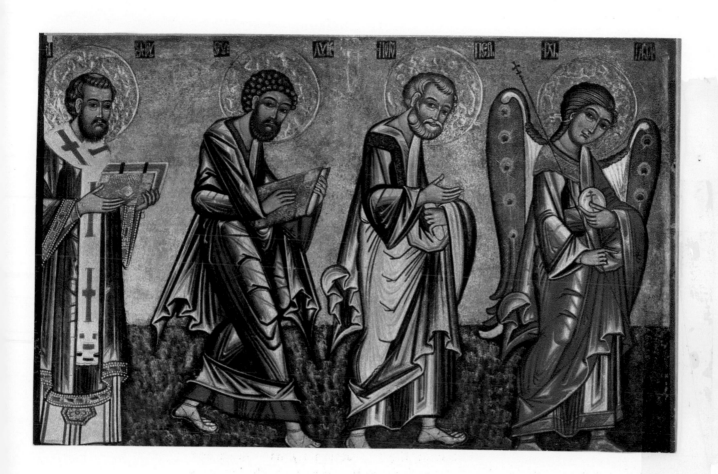

18

THE ARCHANGEL MICHAEL

From the wooden Church in Rovné.

Second half of the 16th century.

Wood, 145×93 cm.

MUSEUM FOR THE ŠARIŠ DISTRICT, BARDEJOV.

Inv. No. 1219.

This large icon of Archangel Michael with individual scenes of his deeds also belongs to the old Iconostasis of the Church in Rovné. The thin raised strip in the border shows a chased decoration of creepers and tendrils; the golden background of the middle section is chased with rhombi which are decorated with rosettes and heart-shaped designs. There are individual scenes in the three outer margins of the icon which illustrate the deeds of the Archangel. They are as follows: 1) God blesses the Archangel; 2) Michael expells Adam and Eve from the Garden of Eden; 3) The sacrifice of Abraham; 4) Michael sends Habakkuk with food for Daniel; 5) The three men in the furnace; 6) The destruction of Sodom; 7) Jacob struggles with the Archangel; 8) Michael annihilates the Pharaoh's army in the Red Sea; 9) Moses leads the Jews into the Blessed Land; 10) Michael appears to Balaam.

The icon is painted in clear, bright colours and excels in the side scenes by its concise and expressive construction. This is particularly so in the scene with Abraham (3) with the dynamic stress of the diagonals. The artist's imagination has found a striking way of representing the serpent (2); its body is coiled round the tree-trunk and ends in a human torso with arms and hands, and a round head on a slender neck.

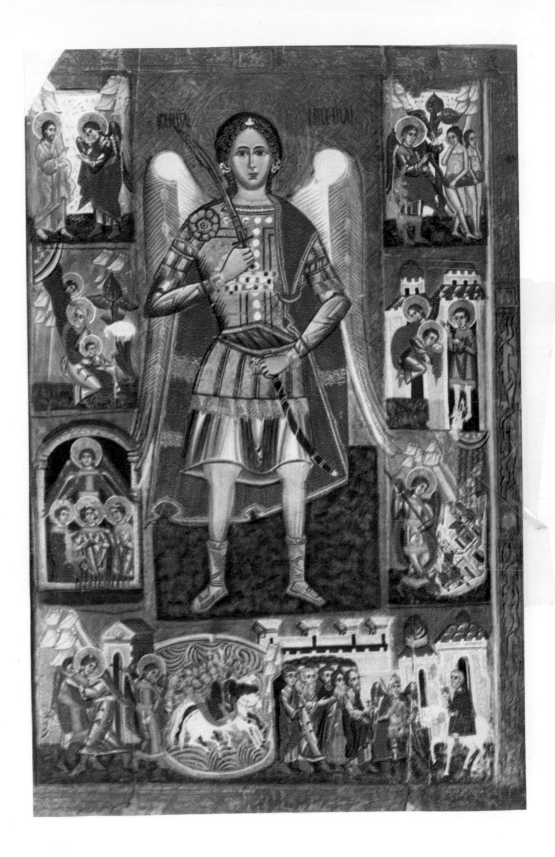

19

THE ARCHANGEL MICHAEL
End of the 16th century.

Wood, 136 × 97 cm.

WOODEN CHURCH OF THE ARCHANGEL MICHAEL, ULIČSKÉ KRIVÉ.

This icon of the Archangel Michael with individual scenes of his deeds is closely related in its iconography to that in Rovné Church (plate 18). The construction of the individual scenes is largely identical. The sequence of the scenes, in which 4) and 6) have been reversed, is as follows: 1) God blesses the Archangel; 2) The expulsion from the Garden of Eden; 3) Michael prevents the sacrifice of Isaac; 4) The destruction of Sodom; 5) The three men in the furnace; 6) Michael sends Habakkuk with food for Daniel; 7) Jacob struggles with the Archangel; 8) and 9) The destruction of the Egyptian army in the Red Sea and the flight of the Jews to the Promised Land; 10) Michael appears to Balaam. When one compares this icon with Plate 18, one observes a softer style of painting. The line of the folds and the lighting are less harsh,

and the colours are mellower. The Tree of Paradise in the expulsion scene is painted more playfully and in greater detail. In this scene the artist's imagination has again been aroused by the serpent who resembles a lizard or a dragon as it climbs the tree on its long legs. Its head too is dragon-like. The resemblance of the central figure of the Archangel on the icon in Rovné Church (Plate 18) to the icon in the Church in Uličské Krivé confirms the observations made in respect of the individual scenes. The green tone of the garment and the bright red of the cloak in the former are full and strong. The golden border and the fine and geometrically precise gold-embroidered stripes on the inside of the cloak bring out the red even more sharply. In contrast, the cloak in the latter is pale green, and in spite of the clever knot on the Archangel's shoulder and the folds of his robe, the red is somewhat lifeless. Michael's face in the icon in Rovné Church is full of energy, with an alert look in his eyes; in the Uličské Krivé icon his face is softly moulded and his eyes are gazing into the distance beyond. The golden armour in the former is decorated with a row of pearls on his neck and a horizontal and vertical line of large white stones. This sharp systematical arrangement is contrasted in the latter by an alternating line of red and blue stones and an undulating ornamental stripe on his neck. The Archangel from Rovné has both legs firmly planted on the ground with both arms strongly folded; the short curved sword points upwards over his right shoulder; his left hand holds the sheath across his stomach and he looks ready for the fight. The Archangel in this plate is more relaxed, his left hand hangs downwards and the sheath is resting on the ground. His

brown wings are articulated by fine golden lines. In contrast to this, the round white area in the icon from Rovné Church offsets a powerful colour accent in the wing-tips with its thick white stripes reaching the contour of the figure. Michael has a stronger, more realistic expression, which is accentuated still further by ornamental stylisation, whereas the Michael from Uličské Krivé Church is gentler and more abstract.

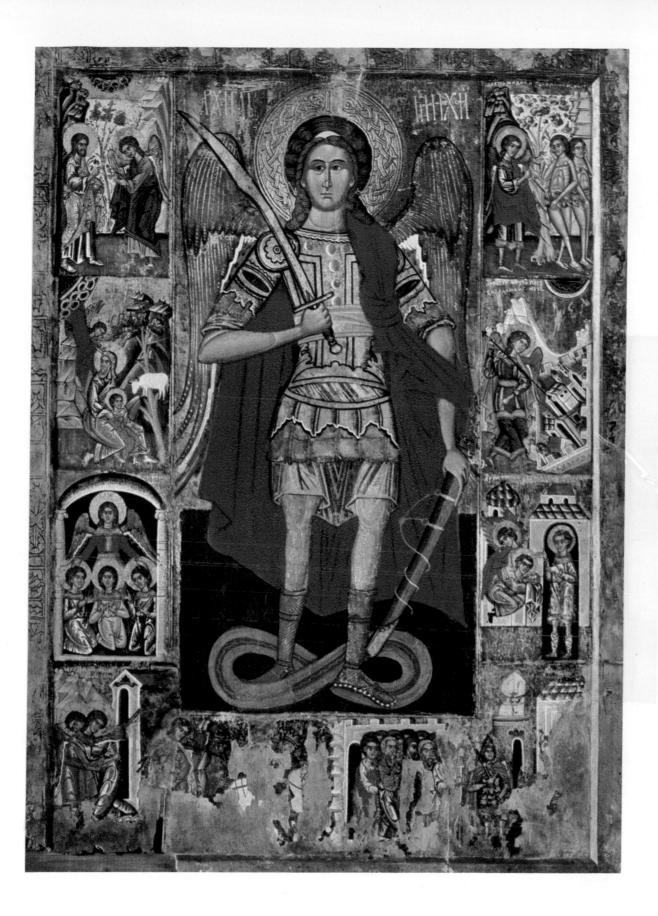

20

THE DESTRUCTION OF SODOM

Detail from the Icon of the Archangel Michael, Plate 19.

WOODEN CHURCH OF THE ARCHANGEL MICHAEL, ULIČSKÉ KRIVÉ.

The destruction of Sodom is portrayed here concisely and symbolically. Once Michael has touched it with his trident, the city, behind which appear terraced crags, crumbles with its walls, houses and temples. Michael is carrying out the command of God, whose presence is suggested by the segment of sky wreathed in cloud in the upper right edge of the picture.

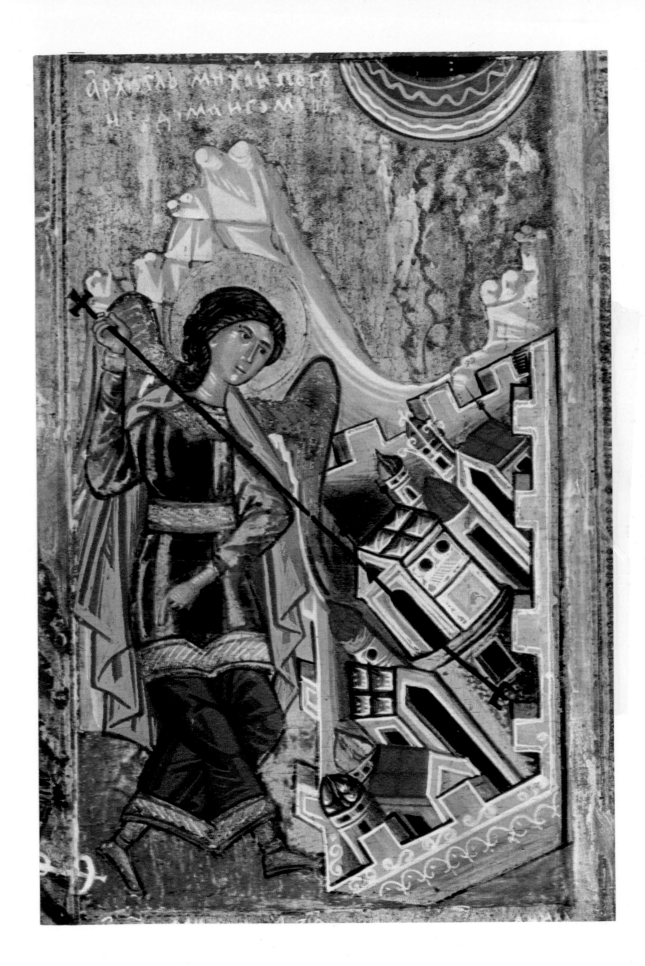

ST NICHOLAS

From the Church of the Exaltation of the Holy Cross in Dubová.

End of the 16th century.

Wood, 138 × 105 cm.

MUSEUM FOR THE ŠARIŠ DISTRICT, BARDEJOV.

Inv. No. 865

St Nicholas, Bishop of Myra in Lycia is among the most frequently painted Saints in icons, and at least one portrayal of him is to be found in almost every church in the Carpathian region, often on a large scale and in the Iconastasis to the left or right of the North Door. A wide gold border with red outer stripes surrounds the deepened middleground of this icon. The life of the Bishop is portrayed in ten individual scenes in the three outer margins of the picture. They are as follows: 1) The birth of the Saint; 2) The baptism of Nicholas; 3) He gives gold to his poor father; 4) His ordination as Archbishop; 5) His appearance to the imprisoned Generals; 6) Nicholas appears to Emperor Constantine in a dream; 7) The burial of the Saint; 8) The bones of the Saint are removed; 9) Nicholas saves a drowning man; 10) The healing of a possessed man. Scenes 1, 2, 4, 7 and 8 correspond to the general iconography of the life of any Saint. The variations are only slight. Scenes 5 and 6 in their general composition adhere to the traditional schema (compare with plate 25). It is worth noting that in this cycle of ten scenes the innocent man being delivered from the sword is missing (compare with plates 25 and 26). Perhaps the artist thought he had sufficiently documented the Bishop's righteousness in scenes 5 and 6. The motif of charity (scene 3) is much simplified here by the confrontation of the father with the Saint, who hands his father the purse of gold. Particularly pleasing in the icons showing Nicholas's life is the scene here of his saving a drowning man, or of his rescuing a ship's crew in trouble at sea (plate 25).

In the middleground of the icon Nicholas is portrayed standing up in the full attire of a Bishop. His right hand is raised in blessing. In his left hand he holds an open Gospel-book with red edges and black script. The text is a variant of Luke 6.17. Beneath his raised arms the sakkos billows out, decorated with a seam of linked crosses. On the exterior, the sakkos is covered with a long row of Greek crosses in circular medallions. The white omophorion with red stripes is decorated with long black crosses. The undergarment is greenish in colour. The Bishop's head is framed by his flowing hair and beard, and the stylisation of his chin gives his head an unusually wide appearence. The background of the icon is golden in the upper section. The lower section has a blackish-grey tinge in the strip of ground. Two shrubs grow from the earth with leaf-shaped flowers.

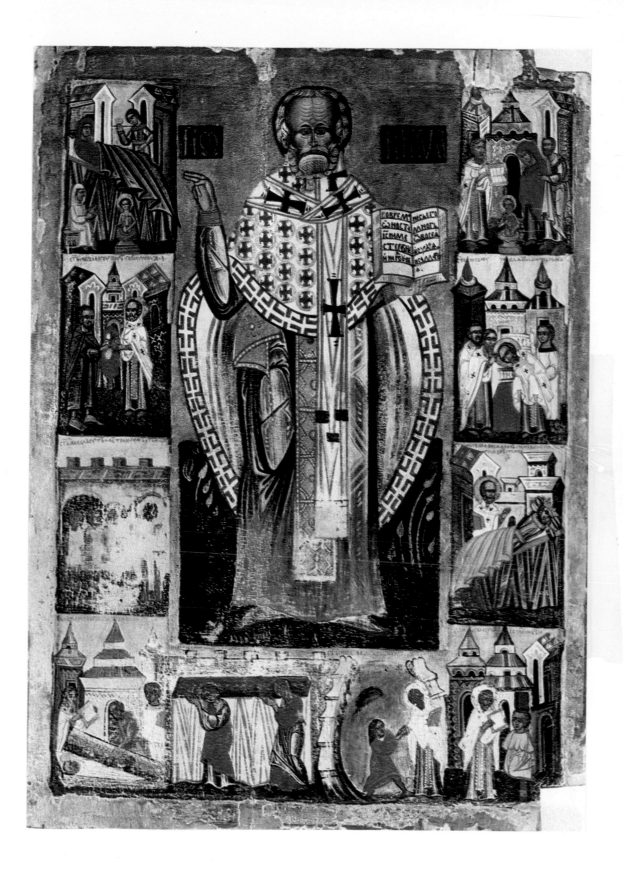

22

ST NICHOLAS SAVES A DROWNING MAN

Detail of Plate 21.

Museum for the Šariš District, Bardejov.

Inv. No. 865

The artist has to a certain extent connected both motifs in this icon. The young man, saved from drowning, is shipwrecked, his capsized boat floats keel-upwards in the greenish-blue torrents. The river bank, or shore of a bay, is enclosed by two curving cliffs. The Bishop stands in his full attire on the bank, the Gospel-book in his left arm, and with his right hand he takes the wrist of the young man, who reaches dry land with a long step. Terror is reflected in his eyes, but also gratitude for his rescue.

23

THE LAST JUDGMENT

End of the 16th century.

Wood, 170 × 130 cm.

WOODEN CHURCH OF ST COSMAS AND ST DAMIAN, LUKOV–VENECIA.

Two angels are rolling up the sky. Christ, Ruler of the World, sits enthroned in a blue aureole surrounded by a red border beneath the strip of sky. The two great intercessors, the Virgin and John the Baptist—as in the Deesis—turn to him for help, with groups of angels standing behind them. In the upper left corner lies the Heavenly City of Jerusalem, with Christ, the Virgin Mary, John the Baptist and Paul the Apostle walking towards it. In the upper right corner the overthrow of the angels is depicted. Beneath the aureole with Christ, the Hetimasia—the throne prepared for the return of the Lord—is placed between two groups of six Apostles. The Gospel-book (Matthew 25,34) lies open on the throne and set up beside it is the cross with the signs of the Passion. Adam and Eve kneel by it and the mouth of the serpent is close behind Adam, depicted (below, right) as the jaws of hell. The hand of God appears below the throne, with the souls of the righteous resting in it, holding the holy scales. From the right a group of rejected people comes for judgment in the following order; Jews, Greeks, Turks, Lyakhi (Poles), Russians and Germans. The red ribbon of the river of fire winds around them, issuing from Christ's feet and ending in the Underworld. The chosen ones approach from the other side in two rows with the forefathers, kings, martyrs in the upper row, and bishops, monks and ascetics in the lower. In a circle below them is Paradise, symbolised by a garden in which the Virgin is enthroned between two angels, with Jacob, Isaac and Abraham seated in the lower part; on the right of this garden stands the good thief. The chosen ones, with Peter and Paul at their head, approach the guarded Gate of Paradise in two groups. The awakening of the dead is depicted in a dark circular area below the row of the damned, and the dead are being called to judgment by trumpeting angels. In the bright central part beneath the throne, an angel drives devils away from the holy scales, while another angel on a mountain-top thrusts a long spear at the Lord of the Underworld, who sits on a two-headed monster in the sea of fire. In the flames one can see the shadows of the sinners. In front of the mountain-top with the angel, the animals are depicted which symbolise the Four Kingdoms. In a fiery rectangle below, the torments of hell for especially bad sins are illustrated, and the normal torments are depicted in five differently coloured medallions. (Fire, darkness, and so forth).

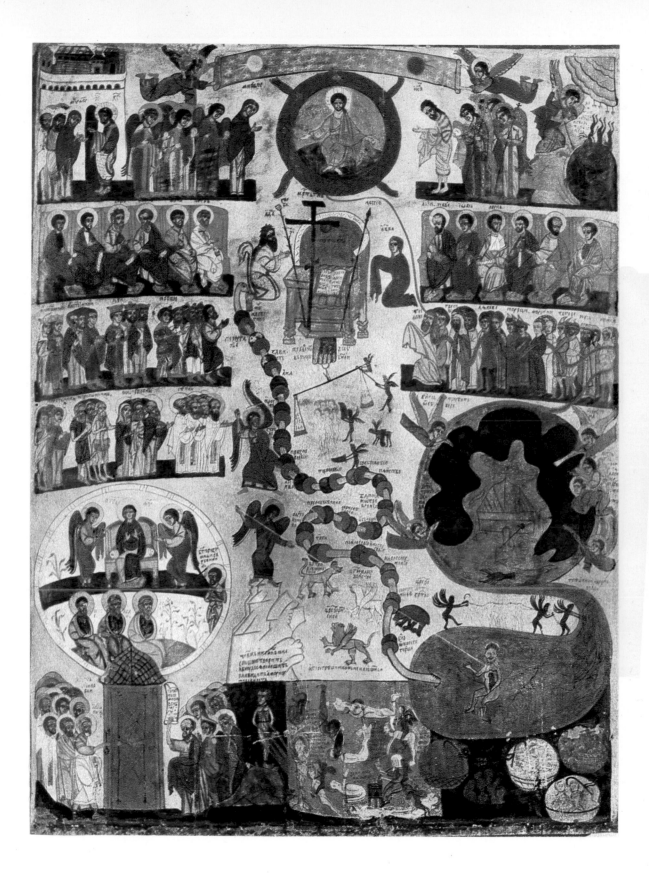

THE VIRGIN HODEGETRIA WITH PROPHETS

From the Church in Rovné.

End of the 16th century.

Wood, 82 × 87 cm.

MUSEUM FOR THE ŠARIŠ DISTRICT, BARDEJOV.

Inv. No. 1214.

This icon is a fragment. It can be assumed with some certainty that additional prophets and possibly Joachim and Anne completed the line. The Hodegetria-type Virgin with the Child on her left arm is portrayed in three-quarter length. The bright red of the maphorion, with its fine gold embroidery, rises up strikingly from the golden background with its relief of creepers, leaves and rosettes. A golden clasp in the form of a rosette links the omophorion beneath the neck-piece which billows downwards in full folds. The undergarment is bright green. The Child's right hand is giving the blessing while his left hand holds a scroll. His white undergarment is embroidered with red and black crosses. The brownish chiton has a rich golden trimming. In the divided areas of the two narrow side margins six prophets are painted full-length, a further two being preserved only in fragments (heads, and objects which they are holding). On the top left is Moses, beneath him David with the Ark of the Covenant, then Habakkuk with the mountain, and a fragment of the head of Amos. To the top right is Aaron with the flowering staff, beneath him King Solomon with an unrolled scroll, then Ezekiel with a gate, and in fragment, Daniel's head and part of his attributes, a stone. The figures of the prophets are on a rich green piece of ground. The painting here infringes somewhat on the decorative parts of the middle area.

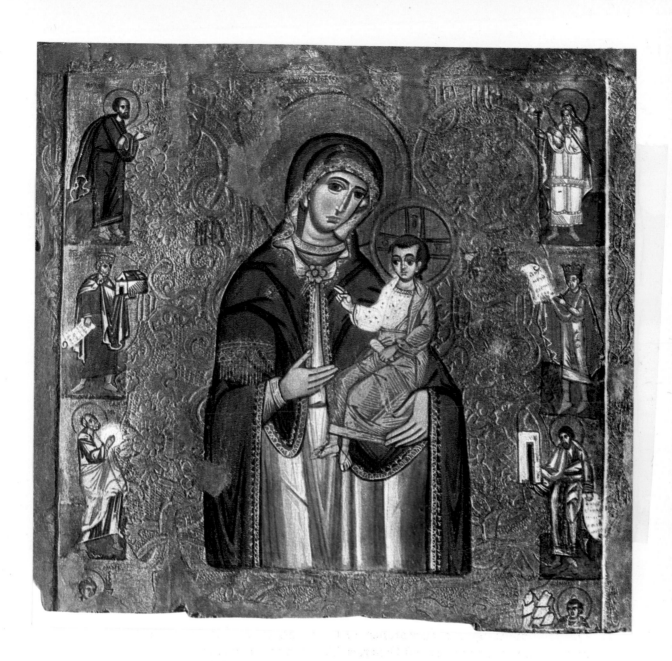

25

ST NICHOLAS

End of the 16th century.

Wood, 134 × 99 cm.

Museum for the Šariš District, Bardejov.

Inv. No. 865/1906, H-952.

The raised border of this icon is decorated with a simple creeper winding round a stick. In the background of the middle area the decoration consists of creepers and rosettes. The blackish strip of ground in the lower section contains a thickly foliaged bush on either side of the figure of St Nicholas. The Saint's right hand is raised in blessing, while his left hand holds an open Gospel-book with the text of John 10, 11—12. The front of the sakkos is adorned with a dense sequence of strictly geometrical red crosses in black and white squares. On the inside the design is identical, but the squares are larger and

1		2	
3		4	
5		6	
7	8	9	10

the artist has tried to reproduce the perspective of the displacement of the drapery. The white omophorion has long and highly stylised red crosses; the undergarment is blue; the shoes red. Nicholas's head is long and oval-shaped and his forehead high. The following scenes from the life of the Bishop are depicted in the margins at the sides: 1) The birth of Nicholas; 2) His baptism; 3) His ordination as Bishop; 4) The healing of a possessed man (driving out the devil); 5) His appearance in a dream to Emperor Constantine; 6) Nicholas returns the son, who has been kidnapped by the Saracens, to his parents; 7) The burial of the Saint; 8) Nicholas prevents the execution of an innocent man; 9) His appearance to the sailors in trouble at sea; 10) His appearance to the imprisoned Generals. The icon as a whole shows a tendency to geometric stylisation, which is apparent in the surface of the table and bed (scenes 1, 4, 5 and 6) and in the shape of the terraced landscape and the painting of the waves (8 and 9). Apart from the red and white tones the colouration of this icon is subdued.

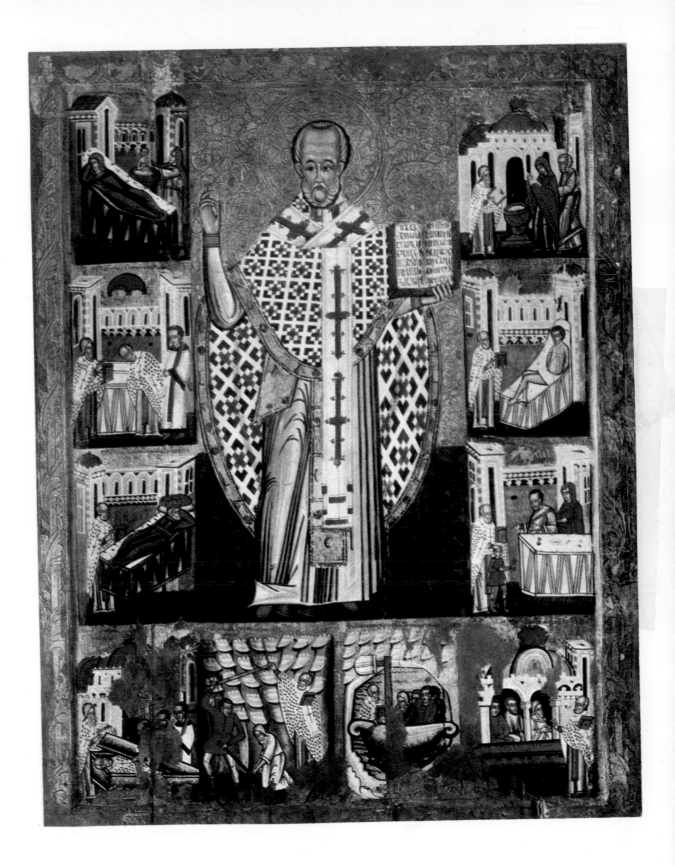

26

ST NICHOLAS

End of the 16th, beginning of the 17th century.

Wood, 120 × 100 cm.

WOODEN CHURCH OF THE ARCHANGEL MICHAEL, PRÍKRA.

The raised outer border of this icon is surrounded by a thin red stripe. A simple band winding in regular waved lines around a stick decorates the border. The middle area of the icon is so arranged, that four scenes from the life of the Holy Bishop are depicted in the two side margins. The narrow rectangular area between shows a full-length portrayal of St Nicholas. His right hand is raised in blessing, while his left hand holds an open Gospel-book with the text of John 10, 11–12 on a maniple. The outside of the sakkos is white and plain, the inside red, with a border seam simply adorned with white dots and blue oval shapes. The undergarment is bright blue; the shoes are red. The omophorion is decorated with long red crosses; epigonation and epitrachelion are red with a blue rosette. The brown ground is dotted with blackish-green clumps of grass and white stalks. The golden background is arranged with parallel double stripes in rhombi, in the middle of which there are rosettes and four-leaved flowers. The eight scenes from the life of Nicholas are as follows: 1. The birth of St Nicholas; 2. His baptism; 3. His appearance to Emperor Constantine; 4. The return of the son, kidnapped by Saracens, to his parents; 5. The saving of a drowning man; 6. The prevention of the beheading of an innocent man; 7. The gift to the three daughters of the poor man; 8. The burial of Nicholas. The artist prefers strong colours. In the marginal scenes he simplifies the structure of the picture and in scene 6 he paints the executioner in contemporary costume.

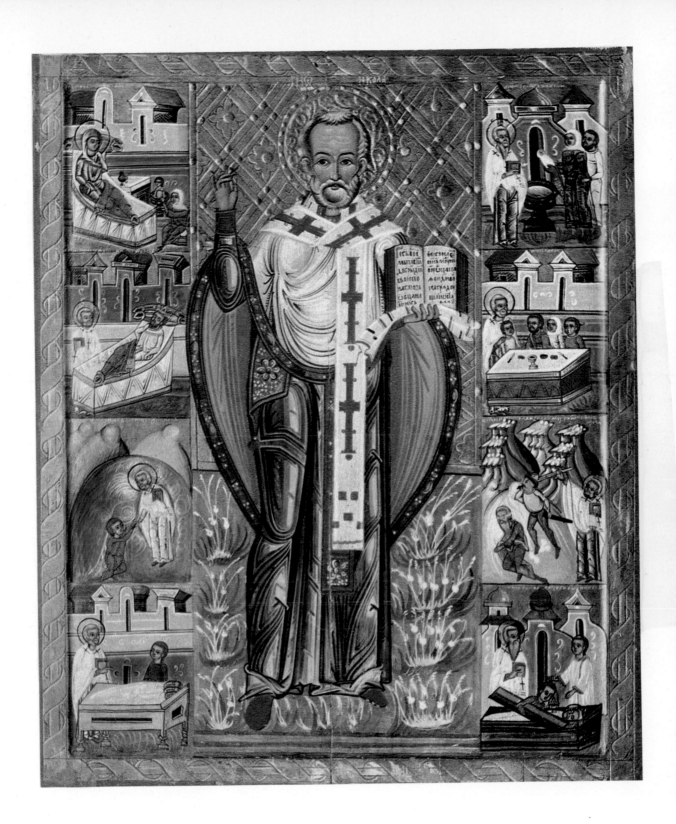

27

ST NICHOLAS

End of the 16th century.

Wood, 116 × 53 cm.

CHURCH OF THE ARCHANGEL MICHAEL, ULIČSKÉ KRIVÉ.

The thin raised border is unadorned and surrounded by an outer wide red stripe. The deepened interior of the icon has a high blackish strip of ground with two delicately painted brown creeper bushes with brown leaves and red flowers. The upper part of the background is arranged with parallel stripes in rhomboid areas, in which a large dot is set. Nicholas's halo is offset against the background by a red stripe. The inscription of the name is written in red above the background decoration.

Nicholas is portrayed full-length. His right hand is raised in blessing, while his left hand holds an open Gospel-book with the text: 'And he came down with them and stood in the plain, and the company of his disciples and a great multitude of people out of all Judaea...', a variant of Luke 6, 17. The outside of the Saint's sakkos is covered with a series of black and red Greek crosses on white squares and has a thin gold seam with rows of pearls on both edges and mounted red stones. The inside of the jacket is plain white, as is the under-garment, which shows only a golden border with red stones on the wrist. The white omophorion is covered with long black and red crosses. St Nicholas's face is framed by his white hair. Beneath his high forehead with expressive eyebrows, his piercing eyes, with large black pupils, look into the distance.

This icon achieves its colourful impression through the sakkos with the black and red crosses on a white background. The contrast to the unadorned white areas of the rest of the clothing is in no way softened by the play of line in the folds of the drapery.

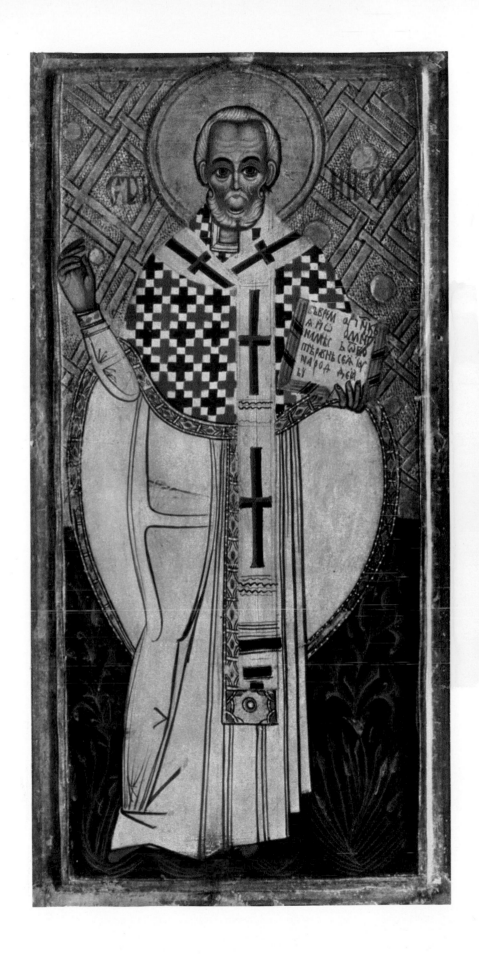

CHRIST PANTOCRATOR

End of the 17th century (later overpainted).

Wood, 95 × 73 cm.

WOODEN CHURCH IN TROČANY.

The deepened interior of this icon is surrounded by a thin green border with a red ornate line. A large pale blue-grey mandorla fills the central area of the picture, leaving space in the four corners only for a simple gold creeper with three-leaved flowers on a red background. The blue-grey of the mandorla is filled with countless angels' heads and wings, the outlines of which are drawn in with thin black lines. Christ is seated on an elaborate high-backed throne in the middle of the mandorla. His feet are resting on a three-tiered oval foot-rest which is the same colour as the mandorla. His robes are dark brown with a golden clavus and golden braided stripes at the neck and on the sleeves. Christ's cloak is whitish-grey. His right hand is raised in blessing and in his left arm he holds a Gospel-book with red page-edges and black writing. The text 'Come, ye blessed of my father, inherit the Kingdom prepared for you from the foundation of the world,' comes from Matthew 25,34. It refers to Christ's office as Judge at the Last Judgment, when he separates the chosen ones from the damned. The halo around Christ's head is red with a cross drawn in black and an inscription meaning: 'The Being'. Christ's head is too small in proportion with his whole figure, which, due to the puffed-out folds of his cloak, gives an illusion of strength. The thin long oval of the face is framed by the full locks of his centrally-parted hair; his dark beard ends at his chin in two sharp points.

The colour of the icon was retouched at a later date, although this does not seem to have altered the artist's original composition.

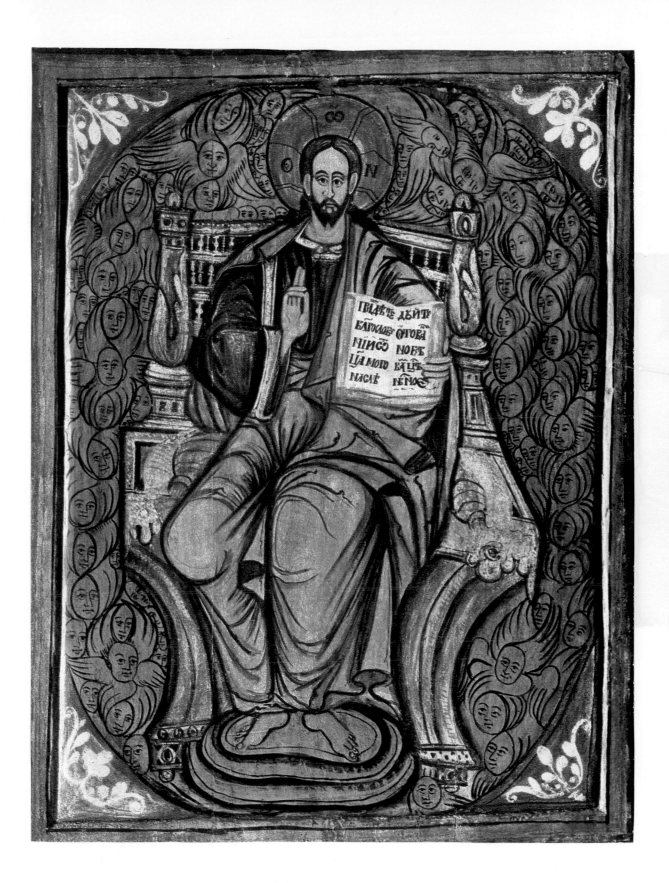

29

THE VERNICLE

Mid-17th century.

Wood, 45 × 67 cm.

WOODEN CHURCH OF THE ARCHANGEL MICHAEL, PRÍKRA.

The raised outer border of this icon has a simple moulding on the inner side towards the painting. The background is golden in the upper part and greenish in the lower part.

Two standing angels hold the Vernicle with both hands, their wings pointing upwards—the Vernicle is the veil with the 'portrait of Christ not made by human hands'. Their blue-green undergarment has a wide black border with fine gold decorative creepers; their red cloak falls in jagged folds across their shoulders. They hold the cloth in such a way that the outer hand of each grips the material from below at the upper corner, the rounded corner thus appearing above their hands. The inner hand of each angel is fully extended and grips the upper edge of the cloth, which is consequently stretched taut and completely unfolded. It forms a curved arch on top, following the halo around Christ's head. The folds of the cloth are drawn in hard blue lines. The decoration of the Vernicle consists of lines of stylised cross-shaped flowers made of red and blue dots and the stems of plants with leaves in the same colours. The back of the cloth, recognisable at the lower edge in the folds of the drapery, is red with a rhomboid-shaped design made of fine gold lines, in the intersections of which short diagonal stripes form stars. Christ's dark head and halo stand out clearly from the middle of the white, cleanly designed cloth. The high oval of his face is framed by thick hair which spreads out in two plait-like locks below the ears. His chin and beard are round; the narrow points of his moustache hang down almost vertically. In Christ's halo which is adorned with large five-leaved flowers is the inscription 'The Being' in the areas where the cross is drawn. In the halos of the angels the chased ornament consists of a series of oval-shaped leaf-tips, similar to those of the Evangelists in the Royal Doors. (Plate 30).

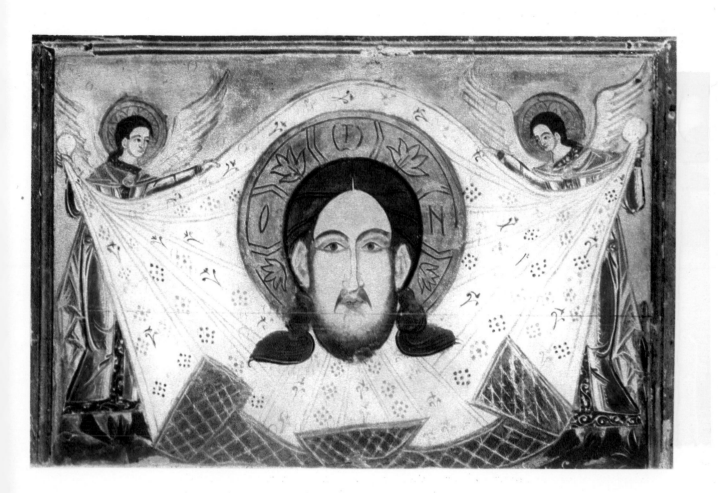

THE ROYAL DOORS

1628.

Wood, 125 × 70 cm.

WOODEN CHURCH OF ST COSMAS AND ST DAMIAN, LUKOV–VENECIA.

The pictorial depiction in this icon of the Royal Doors generally follows the most widely adopted schema: in the two upper sections the Annunciation is portrayed and in the sections below the four Evangelists. The figures of the Virgin and the Archangel Gabriel are standing on a green strip of ground where flowers and shrubs are growing, with a town showing in the background. In his left hand Gabriel holds a small white medallion with the red inscription IC XC, Christ's monogram, instead of the usual staff. The Virgin turns towards Gabriel and supports a heavy open book on her right arm. Beneath Gabriel are the Evangelists, Matthew and Luke, and beneath the Virgin, Mark and John with Prochorus. Matthew, Luke and Mark are sitting on wide seats. They have books on their laps and are writing the first verses of their Gospels, the initial letters of which are written in red. John and Prochorus are backed by a rocky landscape and Prochorus sits at John's feet, writing the beginning of the Gospel of St John. John, also sitting on a wide seat, turns and has his left hand stretched towards the circular segment of sky, his right hand outstretched over Prochorus's head. The haloes of all the figures have chased decoration consisting of a sequence of tongue-shaped leaves, like that of the angels in the Vernicle icon (plate 29); the only halo which is unadorned is that of Prochorus. In the golden outer border and dividing strips, a chased decoration has been engraved which is formed by a series of columns thickening half way up the shaft. This form of marginal decoration is also found in a series of mid-17th century Polish icons, as, for example, in an icon of the Crucifixion, and another of the Archangel Michael dated 1631, which has marginal pictures of his deeds. These icons are in the Nowy Sącz Museum, Cracow. On the Iconostasis door there is a black inscription on the façade of the white building behind Luke, which reveals that this door was intended for the Church of St Demetrius the Martyr, in Lelow. It is usually dated 1628. As yet it is still not possible to say why and when these Royal Doors were taken from the Polish village to the Church in the Venecia quarter of the village of Lukov.

31

DEESIS

First half of the 17th century.

Wood, 130 × 165.5 cm.

WOODEN CHURCH OF LUKE THE EVANGELIST, KRIVÉ.

This Deesis group once formed the central part of a whole Deesis series of an earlier Iconostasis in the Church in Krivé. Today the icons of this series have been put on the parapet of the choir-loft on the west side of the nave. The Deesis group is depicted in the central panel: Almighty Christ enthroned, with the Archangels Michael and Gabriel standing behind the throne, the Virgin to his right, and John the Baptist to his left.

This icon is surrounded by a brown border. The background of the picture is silver in the upper part with a complicated, intricately interwoven creeper decoration in relief. The strip of ground in the lower part is brown with red and white shrubs. The richly ornate Baroque throne of Christ is brownish but on the left side the front support, which has been elaborately turned, and the back leg of the throne are painted grey. The slanting position of the foot-rest is intended to simulate perspective. Christ's face is framed by thick light-brown hair, which is offset by the deep black of his moustache and beard. His garment is painted in various tones of grey. His right hand gives the blessing while his left hand holds the open Gospel-book with black lines of print and red initial letters. The text is a variant of Matthew 25, 34. The Archangels Michael and Gabriel are pointing at Christ with the finger of their respective outer hands; in their other hand they each hold a small white orb with a red cross. The white maphorion on the Virgin, who is wearing a whitish-blue undergarment, is striking and unusual. John the Baptist is wearing a whitish-grey cloak over a grey robe.

The colouration of the entire icon is set by its light tones of colour, their effect being heightened by the silver background and also by the lively contrast of the dark-brown of the ground, the throne and Michael's cloak.

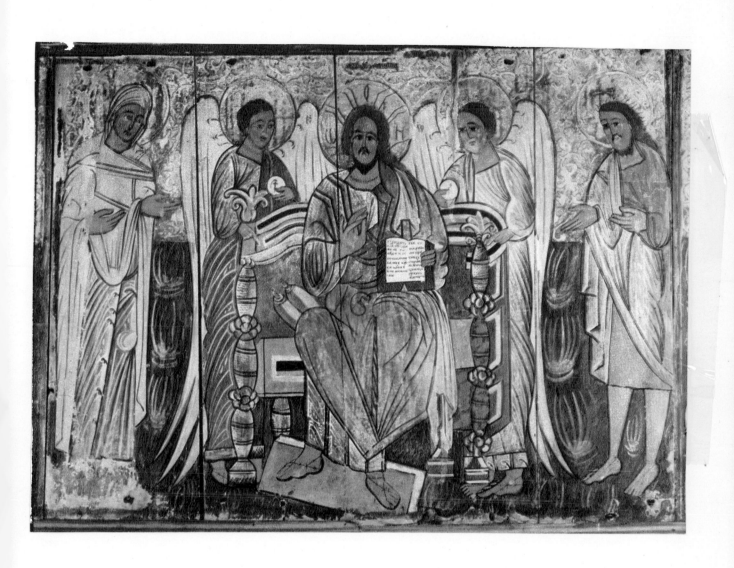

THE BAPTISM OF CHRIST

First half of the 17th century.

Wood, 130 × 107 cm.

WOODEN CHURCH OF LUKE THE EVANGELIST, KRIVÉ.

This icon of the Baptism of Christ belongs, like the Deesis group (plate 31) and the Archangel Michael (plate 33), to the older icon series of the Church in Krivé. Its raised thin silver border has a creeper decoration in relief. A red and a grey stripe edges the border. The silver background is worked in relief in the upper part (as in plate 31). The artist has painted a circular segment of sky in the upper corners, each consisting of three concentric rings in the sequence red–grey–grey, which are pierced by silver rays. A chased group of rays with three points emanates from each of the segments, the one on the left towards Christ; the one on the right towards John the Baptist. A white dove, with folded wings, whose tips interrupt the ornament of the upper border, flies perpendicularly down towards Christ's head. Beside the dove to the left is the writing of the Holy Ghost and to the right the festival's name in red letters. Christ stands in front of the blue surface area of the Jordan. He wears a white loincloth and his forearms are folded round his body. John the Baptist stands to the right of the picture. He is taller than Christ and wears a grey-blue hide, the curls of which are suggested by spiral-shaped lines; the greenish-grey cloak is smooth. His right hand is outstretched over Christ's head. Three flowers, each made up of eight dots around an oval central point, are worked into his halo in relief. The rocky ground on which the figures stand is made of an irregular series of grey-blue areas with uneven parallel white rows of stripes, similar to the sky in the upper sections of plate 33.

33

THE ARCHANGEL MICHAEL

First half of the 17th century.

Wood, 130 × 115 cm.

WOODEN CHURCH OF ST LUKE THE EVANGELIST, KRIVÉ.

The raised outer border of this icon is like that of the Baptism icon (plate 32). Between the portrayal of the Archangel Michael in the centre and the outer borders, there is a series of scenes with the Archangel's deeds in the three margins. They are as follows: 1. God blesses the Archangel; 2. Michael expells Adam and Eve from the Garden of Eden; 3. Michael prevents the sacrifice of Isaac; 4. The Archangel provides Daniel with food; 5. Michael defends the three young men in the furnace; 6. The destruction of Gomorrha; 7. The annihilation of Pharaoh and his army in the Red Sea; 8. Moses leads the Israelites to the Promised Land; 9. Michael before Balaam. The individual scenes are presented with extraordinary conciseness. As in all icons from the earlier series in the Church in Krivé, here, too, white predominates in an assembly of light colours.

The background of the middle section is silver in the upper half with similar relief decoration as in the Deesis and the Baptism icons (plates 31 and 32), and whitish-yellow in the lower half. The middle section is separated from the two side strips by a thin sculptured column in the form of a twisted rope. A pointed arched stripe of the same kind breaks up the ornamental surface. Michael is seen full-face and full-length. He wears a silver and gold suit-of-armour over a grey doublet, the right sleeve of which is short, the left is full and reaches down to his wrist. His hose is grey; his long leather boots white. His fluttering red cloak is held by a massive knot on his left shoulder. His right hand holds the sword; his left hand holds the black, white-banded sheath in such a way that the sword and sheath form an accentuated diagonal together.

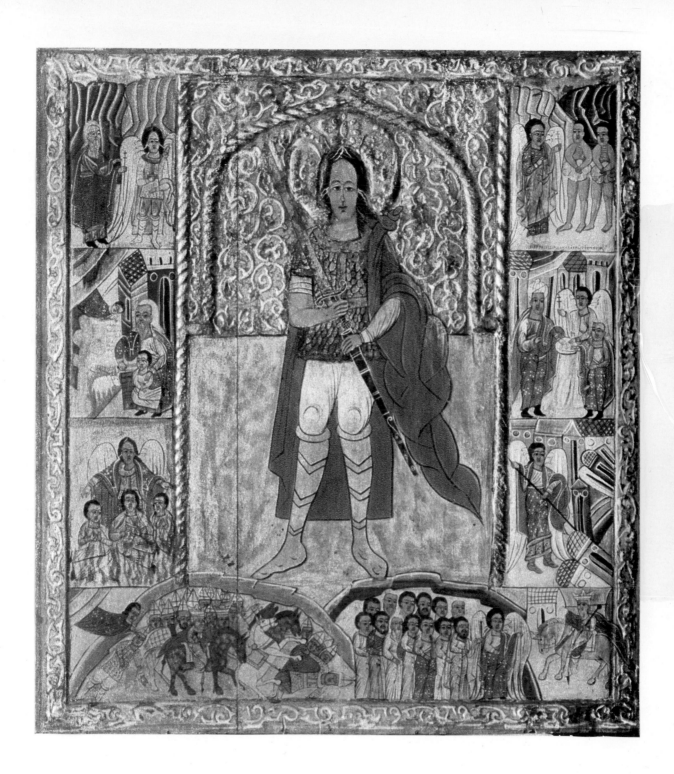

THE CRUCIFIXION

From the Church in Vyšná Polianka.

Beginning of the 17th century.

Wood, 107 × 78 cm.

MUSEUM FOR THE ŠARIŠ DISTRICT, BARDEJOV.

Inv. No. 1220

The blackish border of this icon with its red outer stripe is simply decorated by a group of four round wooden knobs placed at regular spaces on each side. The background is gold in the upper part. Above the horizontal right arm of the cross the moon appears in the form of an orb with a face, and three long rays which descend horizontally towards the cross. The sun on the left is painted similarly, but in red, the moon being blue. The white inscription on the plate of the cross reads INCZ, not INCI, having been adjusted to the local language. A brownish-black halo surrounds Christ's head. Above the blue city-wall of Jerusalem four red crenellated towers appear. The cross stands elevated on a grey-green hill, the surface of which is made up of geometric areas with a linear design in black strokes. In the centre above the lower border of the picture, a black cave is hollowed out, in which lies the large mask-like skull of Adam. The group of white letters, SMLRB, stands for Christ's sacrificial death: the skull's abode becomes Paradise. The women at the foot of the cross form an animated group, trying to console and help the Virgin. The two figures on the other side of the cross are also clearly differentiated: the young John bows his head far down his right shoulder and rests his cheek in his right hand, while his left hand holds a scroll. Behind John, and partly hidden by him, stands Longinus in his armour, gazing up at Christ. An Arabian type of turban is wound round his head. He holds the long spear resting on the ground; its black handle and its point project into the gold of the background above the wall of Jerusalem.

35

THE CRUCIFIXION

1640

Wood, 94 × 94 cm.

WOODEN CHURCH IN MATYSOVÁ.

This square icon has a fairly wide border with painted geometric decoration in red and bluish-green. Four massive gilded wooden knobs are placed at regular spaces on each side of the border. In the upper corners of the picture a brownish medallion has been painted, in which an angel stands behind a rampart. The wings are red with white drawing on the interior. Between these medallions and the vertical beam of the cross is a creeper decoration in fine red lines, on the dark background. The title of the icon is inscribed above the cross in black Slavonic ecclesiastical writing and in white letters in Latin on the horizontal arms of the cross above Christ's arms. Christ's body is highly stylised. On his head he wears a crown of thorns. His feet are turned inwards one on top of the other and are fastened by a large nail. The city-walls and houses of Jerusalem stretch as far as the lower edge of the horizontal beam of the cross. Beside the crucified Christ steep gables appear, on whose ridges black Greek crosses are fixed. On the background of both ends of the beam of the cross, round and heart-shaped flowers in red and white are scattered. To the right of Christ, by the cross, stand three women, Mary Magdalene, Martha and the Virgin Mary. Their hands are outstretched imploringly and their heads are bowed. The young John stands on the other side. He rests his cheek on his right hand and he is bowed in sorrow. The artist has painted his bare feet in such a way that John appears to have two right feet. A second figure of a man with a halo stands behind John, partly hidden by him; this is clearly Longinus. Next to John, and painted full-face, but turned in profile towards the cross with an indifferent expression, stands a warrior with a short red spear in his hands. The red cheeks on the faces are striking; these characteristics are closely related with those of the faces depicted on the church banner in the Nowy Sącz Museum, which comes originally from the Church in Jastrzębik in Poland. This icon can be dated after another one from Matisová whose date is known and which is in the same style of painting.

36

THE VERNICLE

From the wooden Church in Hunkovce.

1671.

Wood, 43 × 70 cm.

MUSEUM FOR THE ŠARIŠ DISTRICT, BARDEJOV.

Inv. No. 1213.

The lateral-shaped icons of the Vernicle were mostly placed on the wall above the Royal Doors. The colour of this icon from the Church in Hunkovce is not very variegated. A double red moulding divides the thin brown border from the painting. The background is yellowish apart from a thin undulating greenish strip of ground. Round-faced, full-cheeked angels with red haloes stand to the left and right. In their hands which are turned towards the outer border they hold up a white branch, while with the other hand they have taken the white cloth of the Vernicle from beneath the upper ends, so that a corner points upwards. The white cloth falls in billowing folds. Due to Christ's halo projecting above the upper edge of the cloth into the background, the halo and head seem to float away from the cloth. The cross is inserted with broad yellow strokes into the red halo, which is surrounded by a grey border stripe. Christ's head has a broad oval shape with accentuated shadows beneath his eyebrows and lower lids. His face is flushed. His hair lies flat across his head and is plaited with several small ribbons. The full beard on his cheeks and chin spreads out into two points. On the background above Christ's halo is the monogram IC XC between red dots. The two groups of letters are separated by a red star made of dots and strokes. On the right, by the angel, the year 1671 is written in black Arabic numerals above the strip of ground. The name Jakon Zazi(?) is signed on the inner side of the angel standing on the right.

THE CRUCIFIXION

First half of the 16th century.

Wood, 117 × 80 cm.

CHURCH OF THE ARCHANGEL MICHAEL, ULIČSKÉ KRIVÉ.

The outer border of this icon is painted red and is slightly raised. In the picture itself, the upper background, above the horizontal arms of the cross, is gold, with chased points between which there are large leaves. A line of clouds moves from each upper corner down to the horizontal arms of the cross, beneath which the background is blue down to the towers of Jerusalem, on which there are white weathervanes. Sun and moon are depicted in front of the clouds. The brown wood of the cross has a regular grain. At the end of the stem the white plaque reaches as far as the raised border; the red inscription is the Latin IN·RI. The crown of thorns is pushed down over Christ's forehead. Heavy brownish-red drops of blood are painted on his arms and body and fall to the ground from his hands and feet. He wears a green loincloth with red decorative designs. At the foot of the cross one can see a mask-like skull with its teeth bared, and beside it bones protrude from the ground. Three women stand by the cross on Christ's right: Mary Magdalene and Martha, with the Virgin foremost. The Virgin's hands are crossed over her breast. The women are arranged in a line and are completely static within the structure of the picture. The figures are elongated, the folds of their robes are indicated by lines. The young John stands on the other side of the cross, his right hand raised in front of his breast, a scroll in his left hand. Captain Longinus is depicted in the background in profile. He is looking up at the figure on the cross, and with the crook of his left arm he holds his lance against Christ's side.

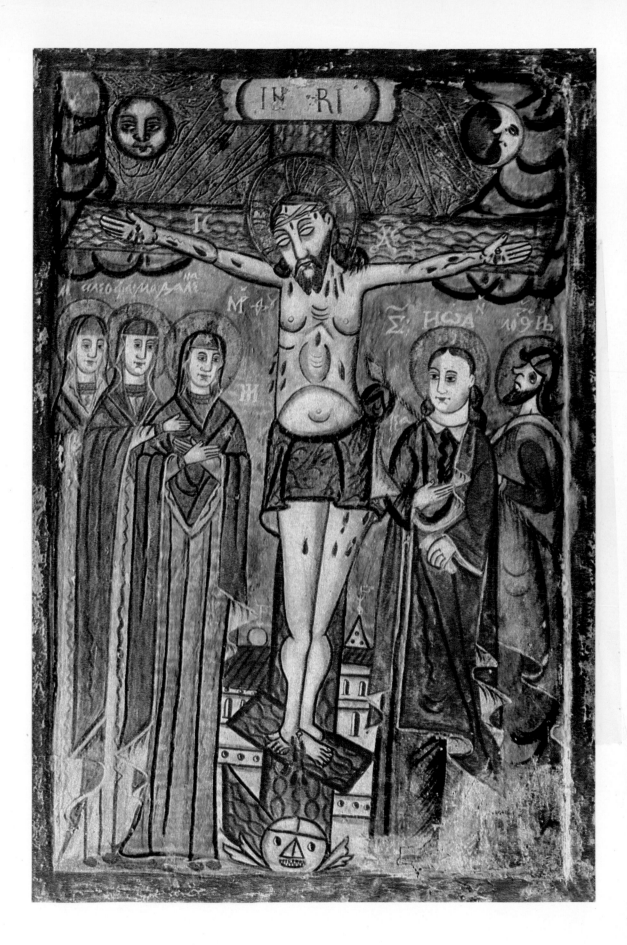

38

THE MARTYRDOM OF ST STEPHEN

Mid-17th century.

Wood, 117 × 56 cm.

WOODEN CHURCH IN KRAJNÉ ČIERNE.

The border of this tall narrow icon is blackish and modestly decorated with a superimposed series of three dots and a long red stripe. The golden yellow background of the painting is traversed by a downward curving arch of clouds, on which sit Christ on the left, and God the Father on the right, with the globe of the Cosmos in his hand. The Holy Ghost, symbolised by the dove, floats up between them with a golden halo in a red aureole of rays. Its wings are spread out wide. At the feet of Christ and God, and still partly painted into the clouds, an angel flies past with outstretched hands: he is ready to take up Stephen's soul. The scene of the martyrdom is depicted below. The landscape is formed by an undulating dark-green strip of ground. On the ridge of the horizon, castles with strong walls and high towers appear to left and right. In the foreground of the field St Stephen is on his knees, dressed in the robes of a Deacon with a red orarion with a yellow cross; his hands are crossed over his breast. His eyes are turned upwards. Four men in contemporary costume stand behind him wearing long caftans, with black caps on their heads; they hold stones in their raised hands. More stones are scattered on the ground round St Stephen. The title of the theme is inscribed with red ecclesiastical writing above the Deacon's head.

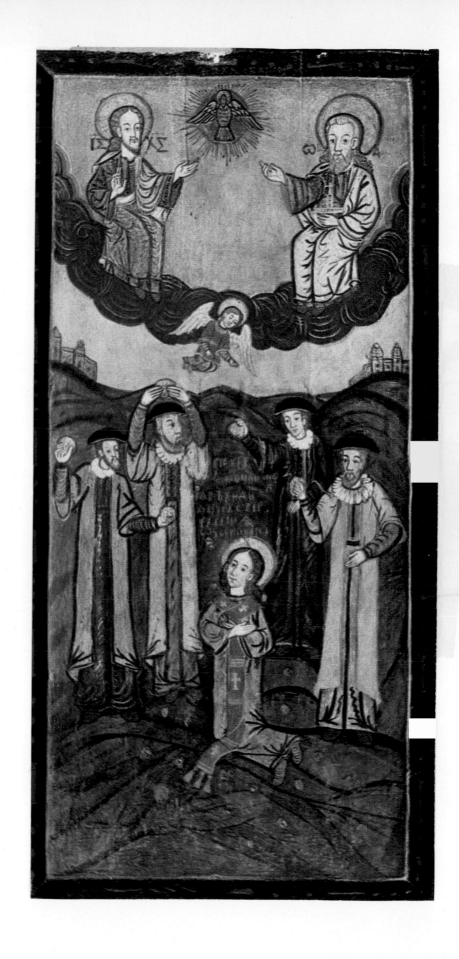

39

THE VIRGIN HODEGETRIA WITH PROPHETS

17th century.

Wood, 105 × 99 cm.

CHURCH IN MIROL'A.

Not only does this icon have a thin raised border strip but the subdivisions of the individual pictures, in which the prophets are depicted, have been made with mouldings. In the central area above the Virgin a moulding has likewise been made in the form of a roof. The two wedged parts at the sides are adorned simply by large sculptured wooden knobs around which white dots have been thickly painted. The background of the actual painting is golden, with a creeper decoration introduced into it. The Virgin, with the child on her left arm, is dressed in a wine-red maphorion, the inside of which is in yellowish tones. The undergarment is bluish. At the neck and wrists it has a yellowish border with pearl trimmings. The Virgin's right hand is pointing at the Child. The dark-haired Christ wears a white undergarment with clavus and over it a yellowish-brown top garment. His right hand is raised in front of him in blessing, his left hand lies on his left thigh and holds a scroll. Twelve prophets are depicted in half-length in the margins of the picture. Each of them holds an unrolled scroll with a prophecy, and some carry symbolic objects. They are in the following order: 1) Aaron; 2) Moses; 3) Samuel; 4) Jacob; 5) Gideon; 6) Zachariah; 7) David; 8) Joel; 9) Micah; 10) Solomon; 11) Jeremiah; 12) Habakkuk.

1		2
3		4
5		6
7		8
9		10
11		12

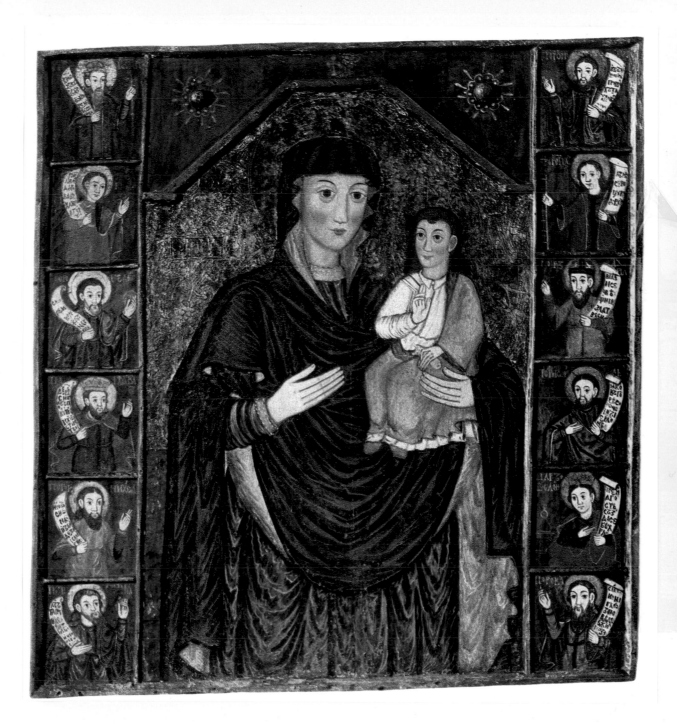

40

THE RAISING OF LAZARUS (Lazarus the Poor)

From the wooden Church in Šemetkovce.

Mid-17th century.

Wood, 120 × 78 cm.

SLOVAK NATIONAL GALLERY, BRATISLAVA.

A narrow raised frame surrounds this icon; the painting is deepened and rounded off by a curved moulding in the upper section. The wedges are grey-blue with delicate white creepers, which were once arranged around a carved flower or a knob. This sculptural ornamentation has not been preserved. A thin reddish stripe divides the lower section and bears the white-lettered title of the scene above: 'Lazarus is Raised from the Dead'. The depicting of the Raising of Lazarus essentially follows a traditional pattern. The rocky landscape of the background is certainly only partly portrayed and to a large extent replaced by the scene of a town. Weathervanes are fixed to the pointed towers of the buildings. Christ appears at the right, walking toward Lazarus and blessing him. The group of disciples follows behind, their hands crossed over their chests. At Christ's feet Lazarus's sisters thank him for hearing their prayer. Lazarus is still wrapped in bandages and stands in the open sarcophagus in front of the dark cave in the rock. Nearby a group of people is amazed by the miracle. The artist has connected the raising of Lazarus with another separate scene in the lower section of the picture: Lazarus the Poor, and the death of the rich man. Propped against a rock with his arms outstretched in entreaty, Lazarus is lying naked on his back. Two spotted dogs rove around him. An angel flies down to him from the sky, to transport his soul to the Peace of God. Opposite Lazarus, in rich fur-trimmed robes, a rich man with lordly bearing stands in front of his retinue. The consciousness of his privileged position is expressed in his bearing. But in the background the figure of Death —the skeleton—has already aimed his bow and pulled taut the string. Two winged hounds of hell with fiery tongues fly towards the rich man to await their prey.

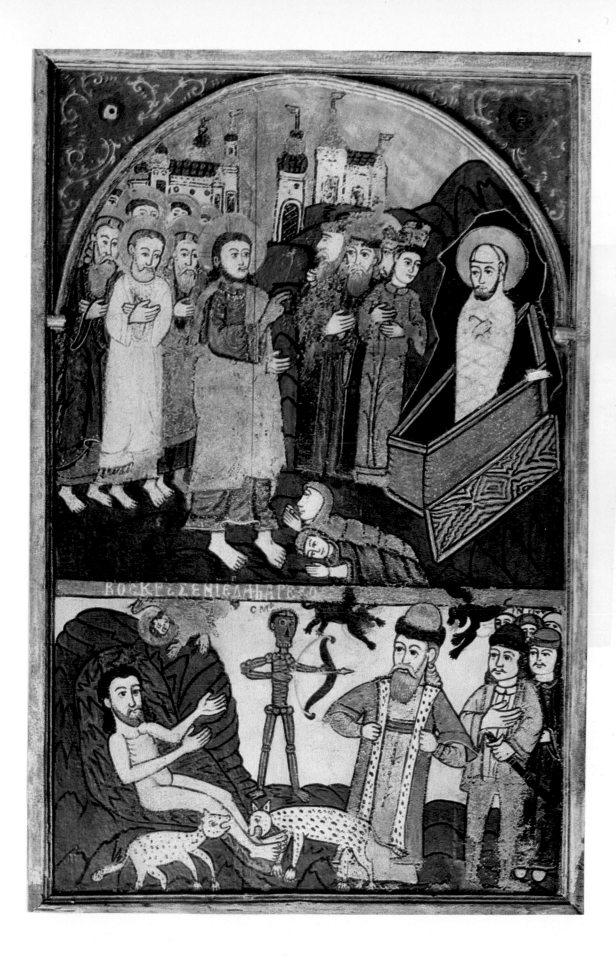

41

THE BIRTH OF THE VIRGIN

End of the 17th century.

Wood, 105 × 95 cm.

CHURCH IN MIROL'A.

This icon is mounted in a rich Baroque frame. Two heavy blue and red columns are on either side, the fluting is in light red. The capitals and bases are partly gilded. The architrave is painted blue and on it the title of the icon is written in white lettering. The salient corner parts of the architrave have a sculptured roof-shaped gilded knob, surrounded by a white painted decoration. In the upper part the painting is rounded off by a carved arch and in the blue spandrels there is a carved gilded flower with pointed leaves. The figure of Anne, resting in the left half of the picture, dominates the painting. She is sitting on a bed with her hands raised; above the head of the bed there is a vaulted purple canopy with a gold border. Anne is wearing a white kerchief, a light blue dress, and has a red blanket about her hips. Joachim stands in front of her with his right hand on his breast. Slightly in the background between these two figures, a serving-girl is bathing the new-born child. Still further back a red cradle stands on the floor of the large room. Mary lies in the cradle and a young boy leans over its side to look at the child. Three women in contemporary costume approach Anne from the back of the room. In their hands they hold vessels with food and drink. Above this group of women the artist has painted the sky. A bluish line of clouds sinks downwards and five long sharp golden rays of light quiver down through the clouds.

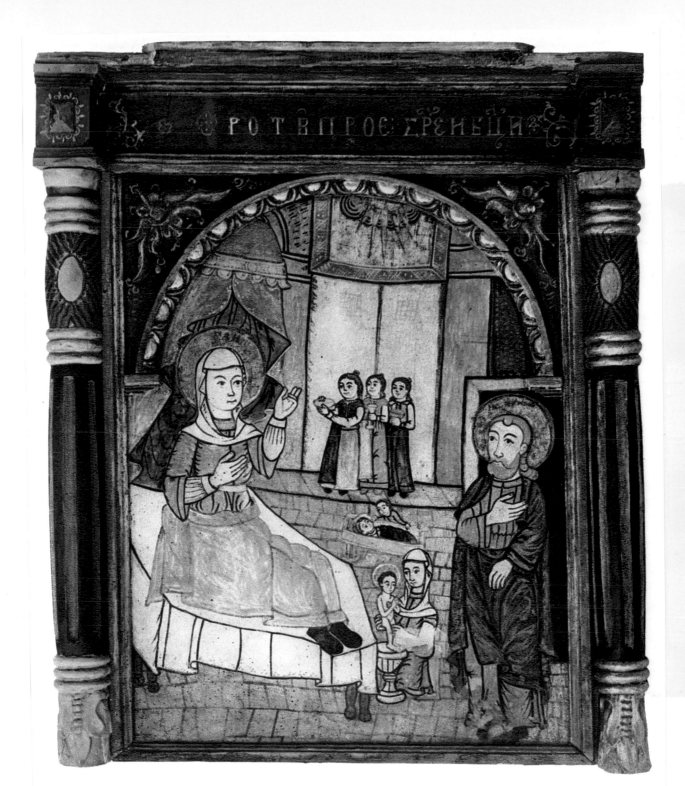

CHRIST PANTOCRATOR

From the wooden Church in Bodružal.

End of the 17th century.

Wood, 79 × 44 cm.

Museum for the Šariš District, Bardejov.

Inv. No. 1206.

A simple frame with one red and one gold strip surrounds this icon. The background of the painting is gilded and has no ornamental design. To animate this free golden surface, the artist has depicted two angels in the upper corners. They are kneeling on grey puffs of cloud, each of them holding a round white medallion; the two together complete the monogram of Christ, IC XC. In the lower corners on both sides of the feet of the throne are two cherubim. Christ's throne is brownish with a grey back. He is wearing the attire of a Bishop, with a crown on his head and the omophorion with red crosses over his shoulders. The yellowish-brown sakkos has a rich ornamental design with creepers and flowers, which are formed by groups of dots. Christ's right hand is raised in blessing, while his left hand holds the Gospel-book open at the text: 'Come, ye blessed of my Father, inherit the Kingdom...' (Matthew 25, 34). The face and neck are formed with brownish shadows.

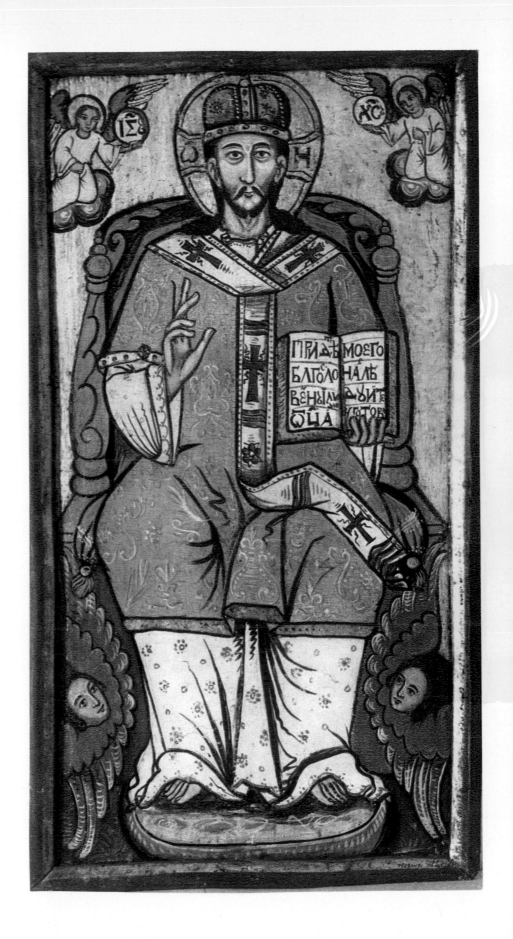

43

ST NICHOLAS

From the wooden Church in Šemetkovce.

End of the 17th century.

Wood, 140 × 125 cm.

Slovak National Gallery, Bratislava.

This icon is mounted in a wide frame with a carved golden creeper. The painting is divided by two vertical plain mouldings into a wide central area and two margins in which scenes from the life of St Nicholas are depicted. In the centre is the portrait of the Bishop. In the upper part the middleground is rounded off by a curved arcade. A gilded carved rosette is set in each spandrel. Only the right one has been preserved. The scenes from the life of St Nicholas are as follows: 1. The birth of St Nicholas; 2. The baptism of St Nicholas; 3. His instruction at school; 4. The healing of a sick woman (a blind woman?); 5. His ordination as Deacon; 6. His ordination as Bishop; 7. The Saint's delivery of a kidnapped son; 8. The delivery of a shipwrecked man; 9. St Nicholas appears to the three Generals in prison; 10. St Nicholas prevents the execution of three innocent men; 11. St Nicholas appears to Emperor Constantine in a dream; 12. St Nicholas drives a devil from a man. The individual scenes are very concise and always remain flat. The same is true of the Bishop in the centre. His bulky figure stands against the golden background with its finely chased creeper. The brown sakkos, which is slit at the sides at knee-height, is unadorned and shows no sign of arrangement or drapery-work. His right hand is raised, while his left one holds a large Gospel-book with metal clasps. Nicholas's face also remains free of sculptural quality and in its treatment resembles that of Aaron (Plate 47).

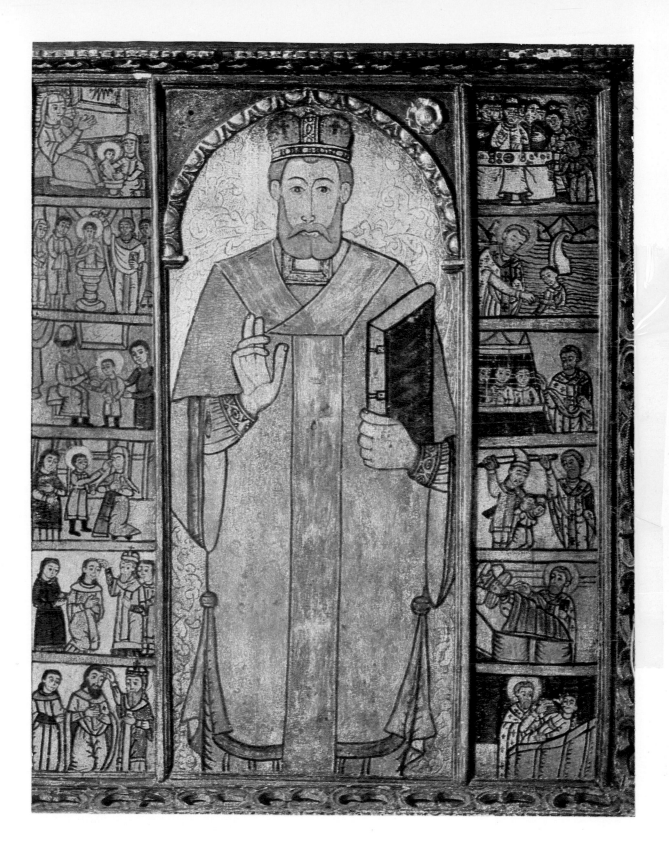

44

THE LAST JUDGMENT
From the wooden Church in Nová Sedlica.
End of the 17th century.
Wood, 187 × 139 cm.
SLOVAK NATIONAL GALLERY, BRATISLAVA.
Inv. No. NL 15.

This icon is surrounded by a reddish-brown border strip. The silvery background
is not deepened and the depiction is essentially flat and graphic. The artist
has not exploited, or wanted to exploit, the possibility of too colourful a con-
struction. Christ enthroned on a rainbow in an aureole is the focal point of
the uppermost part of the picture. The Virgin and St John the Baptist, with
a host of angels behind them, stand beside him, as in the Deesis. Christ's
feet are resting on a globe, which in turn leans on the cross of the Hetimasia.
This cross stands behind a veiled altar, on which the Gospel-book lies open at
the following text: 'Come ye blessed of my Father...' (Matthew 25, 34). The
twelve Apostles sit on either side of the Hetimasia below which one can see the
hand of God. The souls of the righteous are raised up in the arch of his palm
and in his hand God also holds the holy scales, beside which kneel Adam and
Eve. The damned are approaching from the right with the Jews, led by Moses,
at their head. The righteous, here limited to two groups, draw near from the
other side: the hierarchs, martyrs, ascetics and monks. The awakening of the
dead is portrayed beneath the group of Jews. Paradise, a walled city, lies in the
lower left corner; here the Virgin Mary and below her the forefathers Isaac,
Abraham and Jacob, await the redeemed, who walk towards the Gates of
Paradise. At their head comes Peter the Apostle, with an angel bringing up
the rear of the procession. Death, with a scythe and hour-glass, stands above
this angel on a brown crag. The remaining part of the painting is occupied
by sinners, devils and hell. A strip, widening out into the fiery river, emerges
from the apex of the scales and enters the jaws of hell in the lower right corner.
In this river the vast horde of sinners is suggested by a multitude of heads
which are being pulled down into the jaws of hell by a strong current. Devils
chase and torment the souls of the sinners in isolated scenes on either side of
the river.

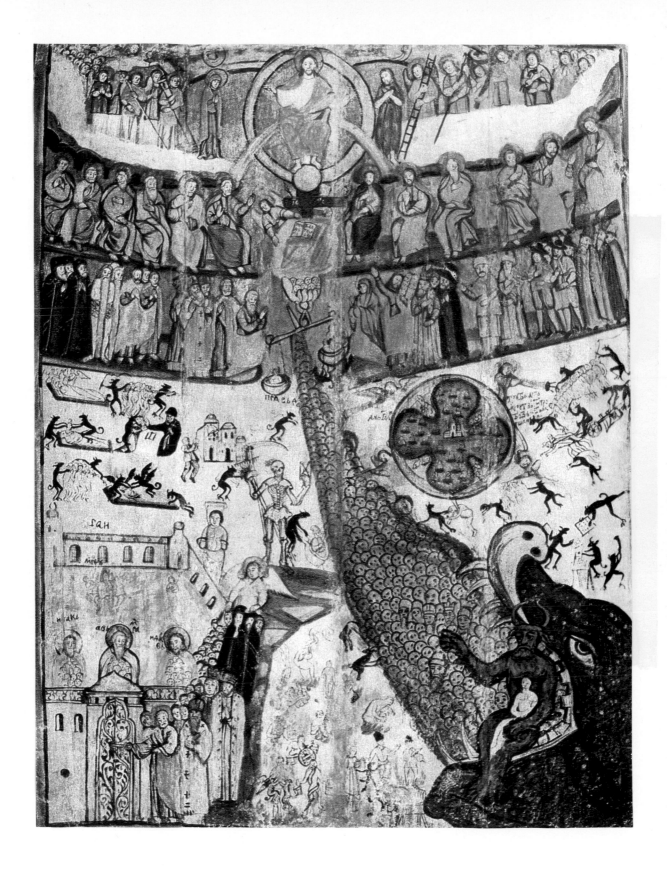

45

THE VIRGIN HODEGETRIA

1654.

Wood, 132 × 85 cm.

WOODEN CHURCH OF ST COSMAS AND ST DAMIAN, LUKOV–VENECIA.

The wide inner stripe of the frame of this icon is painted blue. In the corners of this inner stripe there are carved gilded rosettes with red flower pistils. In the lower corners they have not been preserved. Sculptured oval knobs decorate the middle of the four border strips, surrounded by a rich white creeper ornamentation. The painting of the icon is rounded in the upper section. The arch of this rounding is here formed with the simple decoration of two painted strips in brown, red and green. In each of the spandrels the artist has depicted an angel's head and wings on a red background. The Virgin, in three-quarter length, carries her Child on her left arm. Both she and the Infant Jesus are crowned. The Virgin's right hand is pointing at Christ, while her left hand supports and holds the Child. The infant has his right hand raised in blessing and with his left hand he presses a book with ornate covers to his body. The Virgin's brown maphorion has a border of creepers at the hem and shows a flower design that is formed out of five large and four small dots for each bloom. Her undergarment is blue-green and has a wide red border at the neck. Christ is wearing a white himation with a red belt, which is joined to a large bow under his chest. His top garment is a chiton with a rich gold trimming.

In the lower part, above the gold moulding that separates the picture from the frame, the artist has left a broad white space for an inscription, which recounts that this icon of the Virgin was painted for the Church of the Nativity in Nowa Wes in 1654. The village of Nowa Wes lies beyond the ridge of the Carpathian mountains in Polish territory.

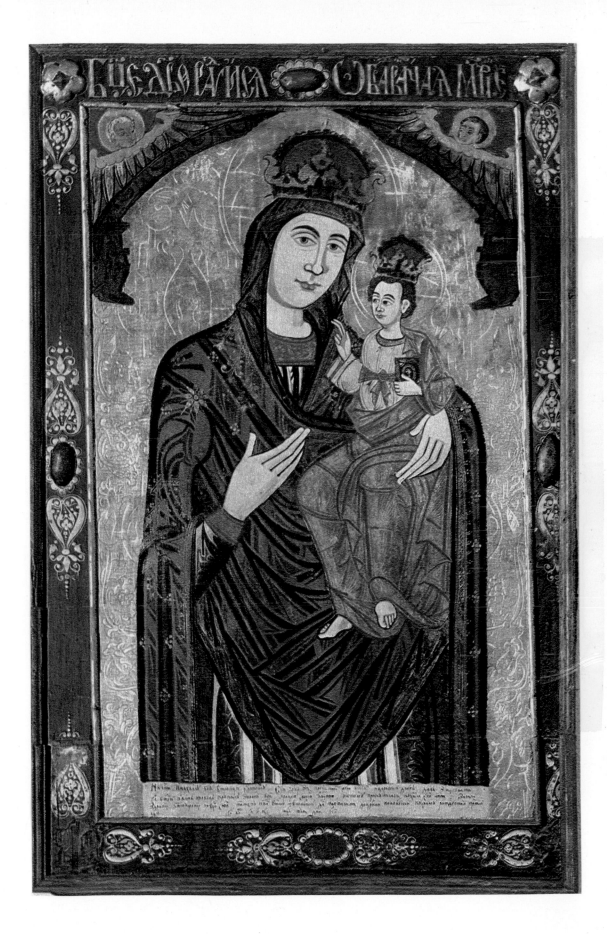

46

CHRIST TEACHING

End of the 17th century.

Wood, 122 × 67 cm.

WOODEN CHURCH IN KRAJNÉ ČIERNE.

This icon is surrounded by a frame whose surface is painted blue. In the corners there are sculptured square knobs which are tapering towards the ends. In the centre of each of the four side strips is a gilt sculptured oval knob: This simple relief ornamentation which suggests precious jewels, is encircled with white creeper designs and stars, simulating metal clasps. Towards the centre the frame is offset by a simple gold moulding. Somewhat more than half of the gold background of the icon is decorated with finely executed wide creepers. A green strip of ground suggesting hump-shaped hill formations runs along the bottom of the picture. In the foreground stands Christ dressed in an off-white and grey-green cloak, beneath which a reddish undergarment with a clavus and white dotted patterns is visible. His right hand is raised in blessing, while his left hand holds from below an open Gospel-book with red page-edges. The text reads: 'Come unto me, all ye that labour and are heavy laden...' (Matthew 11, 28). The halo which is contrasted with the background by a double line, has the Sign of the Cross and the inscription O ON. On either side of Christ, in the upper corners, the Virgin and John the Baptist are painted in half-lengths. They are floating on four puffs of cloud and their hands are crossed in front of their bodies, palms inward. Through these two figures the theme of Christ teaching is here made into a form of Deesis. Christ's monogram IC XC is written on the background in two rectangular areas on either side of his neck. The face of Christ is dominated by two large eyes and the fullness of his beard and hair. His ears are prominent. With the reddening of the cheeks and soft shadows the artist has achieved a suggestion of plastic quality. The shape of the drapery is full, but unmotivated and shows that the artist was still unpractised in subtleties such as these.

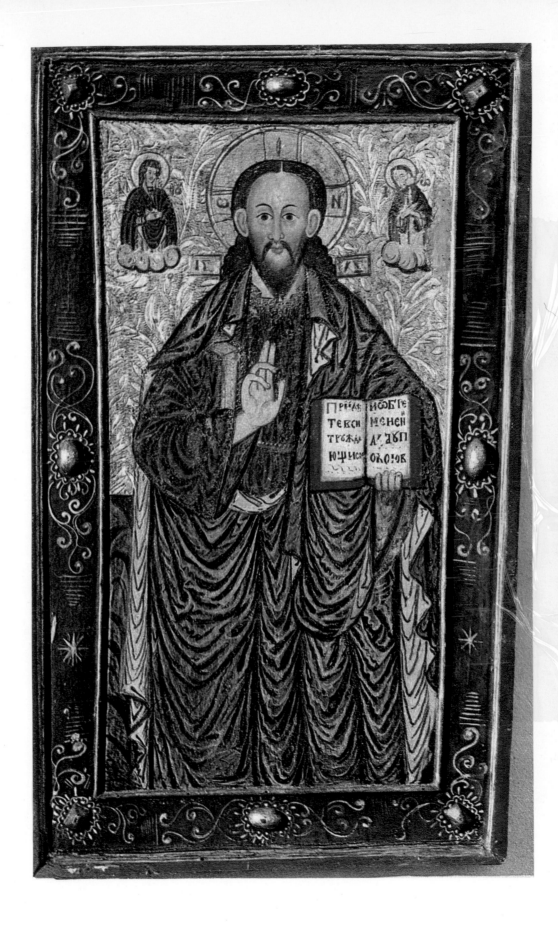

47

AARON

From the wooden Church in Rovné.

Second half of the 17th century.

Wood, 160 × 70 cm.

Museum for the Šariš District, Bardejov.

Inv. No. 1221.

This tall icon is surrounded by a thin red frame with gold moulding on the inside. The painting is rounded off in the upper part. The spandrels have a painted gold decoration of tendrils around a sculptured gilded semi-spherical knob. The background of the icon is blue-green. The lower part, in a brown and red colour with black bordering the individual areas, tries in vain to convey the impression of a deep space. Aaron stands in the focal point of the picture. On his head he wears a crown with a headband on his forehead. A similar band runs from the centre of his forehead over the crown to the back of his head. A white cross is fastened at the apex on a golden knob. The long oval of his face is painted as a one-dimensional and has no plastic quality at all. His ears are prominent. His hair and beard are greying. His long beard is divided by a black central line, and the hairs of the beard run towards it in a fish-bone design. Aaron is dressed in a short red cloak with a gold pattern and black hems. The full sleeves reach below his elbows. His forearms are folded down to the golden girdle which encircles his waist above the robe. In his left hand he holds a censer by three long chains. Black puffs of smoke curl up from the pierced lid of the censer. His right hand holds an unrolled scroll, the text of which tells of his prophetic presentiment of the coming offspring from the stem of Jesse.

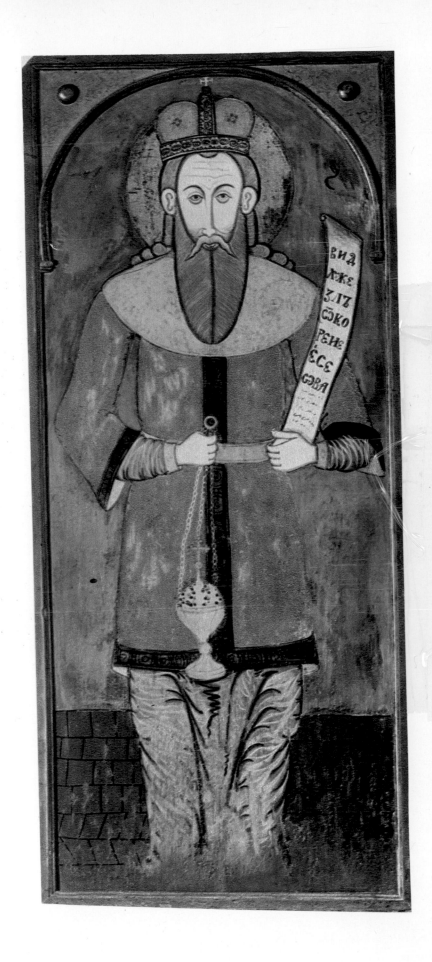

48

ST NICHOLAS

Second half of the 17th century.

Wood, 165 × 110 cm.

WOODEN CHURCH IN LADOMÍROVÁ.

As is testified by the selection of plates in this volume, St Nicholas is one of the most frequently portrayed bishops of the Eastern Orthodox Church. It is however only in later icons that he is painted in the full splendour of his vestments; earlier pictures preferred the decorative but modest polystaurion. The painter of the Ladomírová icon is among the Baroque artists who considered the insignias of office especially important, because they were in harmony with the solemn pathos of the time. Framed and rounded off in the form of an arcade in the upper part, this icon portrays Nicholas in three-quarter length, standing partly behind a table. On his head he wears a preciously embroidered mitre decorated with jewels and the cross. The omophorion is red with golden hem and large gold crosses. The cross on his chest is suspended on a golden chain; the ends of the cross are formed by four cross-shaped circles joined together. The dark sakkos has a rich plain-coloured tendril design. His right hand leans on his crosier and holds a maniple. His left hand rests on the front of a large Gospel-book placed on a table, with a cross and signs of the Passion on the binding. An ink-well with a quill stands on the table, and beside it a sheet of parchment partly unrolled. Behind St Nicholas's shoulder the three cupolas of a cathedral are visible in the style of the Baroque churches of the Carpathian region and the Ukraine.

The artist's intention was to paint a genuine portrait of St Nicholas in this picture, and it is possible that he used a contemporary bishop as his model. This would not be an unusual practice for an icon painter of the time. The severe face painted delicately and naturally shows an individual character and hardly recalls the typical features of Nicholas as depicted in early icons.

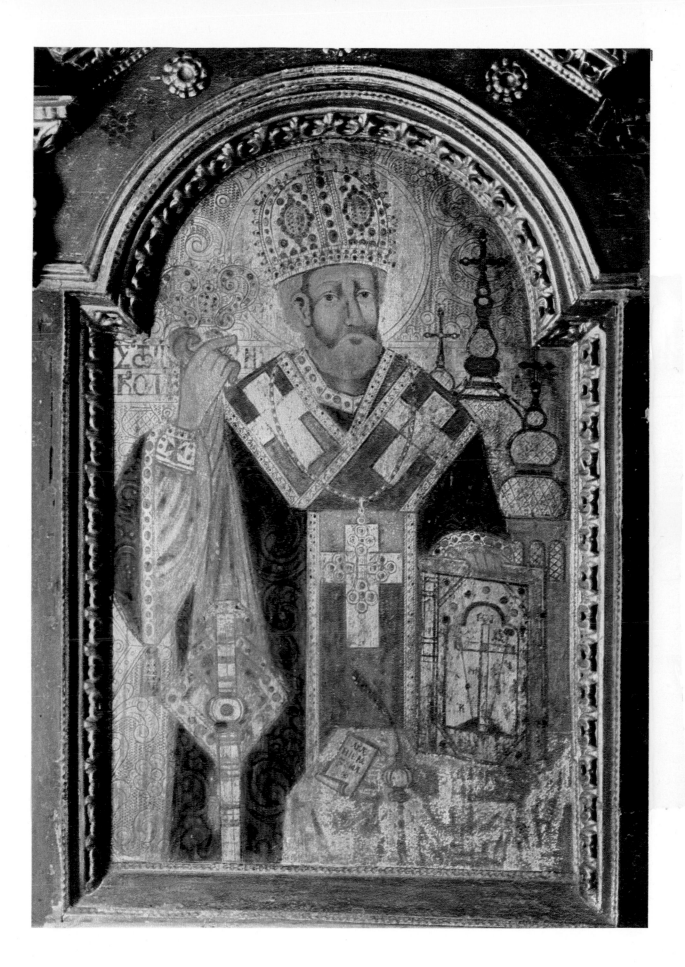

ST JOHN OF SUCEAVA.

From the Church in Nižná Jedľová.

Wood, 89 × 59 cm.

MUSEUM FOR THE ŠARIŠ DISTRICT, BARDEJOV.

Inv. No. 54/62, H-3163.

The Saint referred to in the inscription of this icon, *SIOAN' SOUIAVSKI*, is a martyr who is unknown among Greek synaxarions. According to Greek hagiologists, he died at the hands of the Turks in Cetatea Alba in the 15th century (in Turkish, Akkerman; in old Slav, Byelgorod, i.e. White Town), Cetatea Alba being an important town on the bank of the estuary of the Dniester. St John of Suceava was a merchant born in Trebizond. In Rumania he is known as Ioan cel Nou; John the New or the Younger. His martyrdom by the Tartars is placed at about 1360. This date could well be authentic, because Prince Alexander the Good had his bones removed to Suceava, the capital of Moldavia, in 1402, where they were then put in the Mirauti Church and, in the 16th century, in the archiepiscopal Church of St George.

The wide frame of the icon surrounds the tall oblong picture with an undulating grain effect. Above the Saint's shoulders there is a thin gilded arcade, which rests at the base on a simulated abacus. The two spandrels are painted in bright blue on which are symmetrically arranged simple creepers in gilded relief with double loops and three pointed leaves. The gold background of the picture has a finely executed and richly twined creeper and flower decoration, ending at the halo which surrounds the outline of the face and is offset by a double line, and the two angels above John's head. The Saint, portrayed in three-quarter length, wears a white undergarment dotted with green creepers and the red martyr's cloak with a thin gold border. His right hand holds a long-handled cross, decorated with corals or jewels, which corresponds to the contemporary Carpathian custom, in the ornamentation of its ends and the diagonal points at the intersection of the arms of the cross. In his left hand he holds a sword by its hilt from his waist, with the blade pointing straight down at the ground, and a long palm leaf, which projects above his left shoulder into the golden background. The cross, sword and palm are symbols of his martyrdom. The Saint's head is framed by curling hair and a short beard. The pupils of his eyes are set slightly askance and he looks beyond the spectator. The reddening of his cheeks and the softness of his skin lend his face an inspired expression. Two small angels float above his head, holding the martyr's triumphal wreath; in their other hand they hold a long-stalked bell-shaped flower.

In the treatment of the folds of the cloak and in the somewhat plump form of the small angels, the artist betrays certain failings. The icon as a whole belongs to the group of paintings which in their basic conception still cling to old traditional forms, but which show an acquaintance with Western painting from their own perception and also pay tribute to the spirit of the late Baroque—not only in their ornamentation but also in the more realistic details and a certain solemnity.

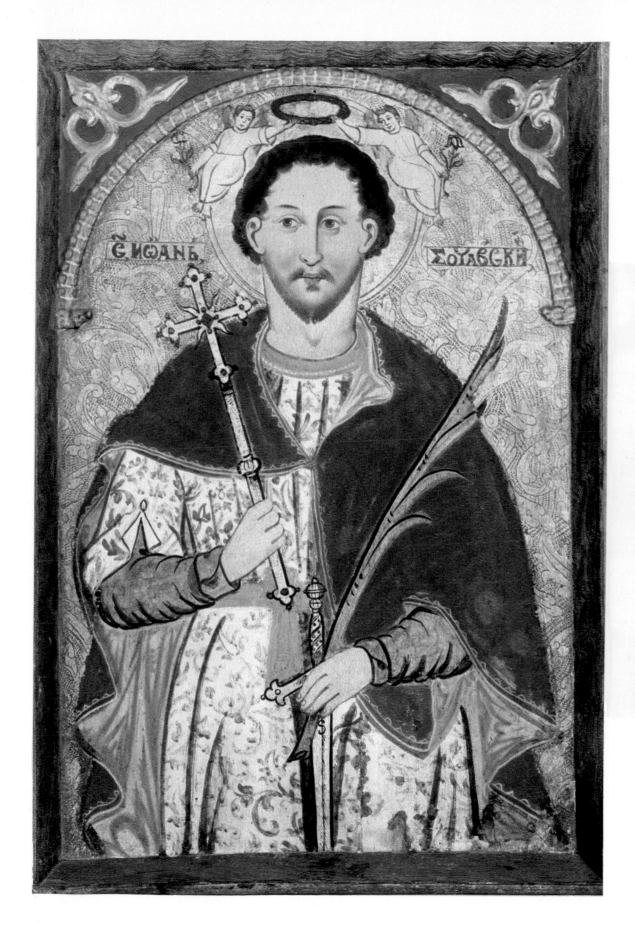

50

AARON

South door of the Iconostasis in the Church at Kurov.

1656.

Wood, 135 × 54 cm.

Museum for the Šariš District, Bardejov.

Inv. No. 774.

The side doors of the Iconostasis are generally worked from a single piece, and thus do not have two door-leaves as do the Royal Doors. The Prophet Aaron, his name written in Church Slavonic, is often portrayed on the south door: the door with the diaconal icon. Aaron is painted in full length. His white undergarment has gold-embroidered wrist borders. On top of this he wears a shorter robe, ending above the knee, the lower edge of which is covered with small spherical bells. The brownish-red top robe, which is slit to the waist, is lined with green and surrounded by a gold border at the neck, shoulders and ends of the sleeves. Aaron is wearing a rectangular golden disk on a chain round his neck with twelve rhomboid-shaped ornaments arranged side by side in four rows of three. His right hand is raised above the wide golden belt and holds a censer by a chain, with his thumb stuck through a ring. At shoulder height his left hand clasps a heavy long staff, from which sprouts a fine creeper with two large blooms. On his head Aaron wears a dark-brown hood, which ends in two horns and which is pulled down over his forehead so that the golden edging rests above his eyebrows. Below the edging a semi-circular piece has been added to the sides, covering the Prophet's temples and ears. A vertical gold border runs from his forehead to the back of his head between the horn-like tips of the hood. His hair hangs down his shoulders, and his long, neat, white beard reaches down to the disk. His large fleshy nose, his full mouth and the reddening on his cheeks give the face a realistic expression. His head is turned slightly towards his right shoulder, the look in his eyes is slightly strained and directed inquiringly in the other direction. Even if the Prophet's dress and attributes adhere to traditional patterns, this realistically orientated painting with the delicate brush strokes is clearly hallmarked with Western conceptions. That is why this icon stands on the threshold of purely Catholic works of the turn of the 18th century.

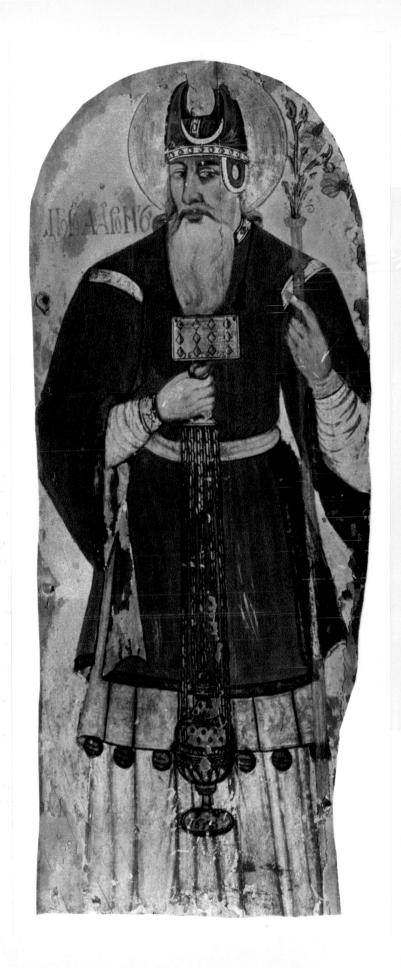

51

THE DESCENT FROM THE CROSS

Icon from the altar-piece in the wooden Church at Krajné Čierne.

Beginning of the 18th century.

Wood.

WOODEN CHURCH IN KRAJNÉ ČIERNE.

This icon is on the altar-piece in the wooden Church at Krajné Čierne. It is one of a fairly large number of icons which are mounted in huge, complex frames. The frame consists of a comparatively low stand with a panel placed centrally in front of it on which the cross is depicted with spear and staff; the letters NI KA (i.e. conquers) and MLRB (the initial letters of the Slavonic ecclesiastical dictum 'The Calvary becomes Paradise') are grouped around the brownish-red cross in white writing. The parts of the base below the lateral columns have a simple relief decoration formed by eight points which encompass a rounded, cylindrical central piece. Columns stand to the right and left above the base, flanking the painted surface of the icon itself. The simpler, gilded creeper work of the columns winds round two large bunches of grapes, the upper being golden, the lower green. The capitals, in simplified acanthus form, become a slender abacus, on which a carved angel's head with wings forms the crowning point. The frame runs above the angels into a roof-shaped slope which joins on to a horizontal plinth beyond two deep oval notches. Another winged angel's head is placed beneath this plinth. Two golden rosettes, on the red area between the angels, complete the decoration of the frame. An open gilded creeper with two bunches of grapes is added to the sides, continuing, without any decoration, up the roof-shaped slope and surrounding a round gilt medallion with the portrayal of a seraph on the finial, which ends in a leaf. The heaviness of the massive frame is optically relieved through this outer creeper.

The theme of the painting is the Descent from the Cross. The figures on the thin black ladders have placed Christ's arms over their shoulders and are holding the large pall. A holy woman clings to Our Lord's feet and presses her cheek hard against them. The Virgin is in the foreground, separated from the scene. She turns her back on the cross and collapses with sorrow. Her sorrow is symbolised by a sword which is puncturing her heart and to which her right hand reaches out. This motif is borrowed from Western iconography. The signs of the Passion are depicted in the dark ground at the Virgin's feet. This altar-piece icon is a typical example of the increased merging between Eastern and Western religious painting which developed at the end of the 17th century.

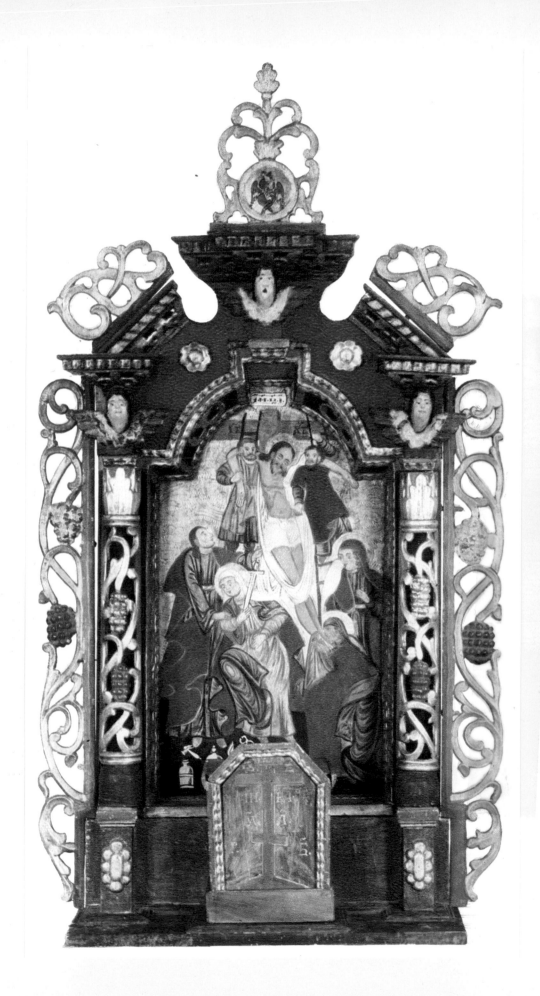

ST GEORGE

From the wooden Church in Nová Sedlica.

Beginning of the 18th century.

Wood.

SLOVAK NATIONAL GALLERY, BRATISLAVA.

Inv. No. NL 16.

This icon of St George and the dragon is mounted in a Baroque frame, with the result that the actual painting is set back. The sides of the frame are brown; the upper part is red. A gold decorative moulding serves as a partition and follows the curved arch in the upper part of the icon. The two sloping parts of the frame join at two column sections, the abacus of which lies at the top of the vertex of the arch; then comes the horizontal final moulding with a deep incision. The edge of this upper frame consists of three carved strips: the innermost one is a narrow gilded strip with a twisted design, the central one has a rounded variegated dog-tooth design, and the outer is silver-plated and twisted. Between this edge and the gold moulding above the icon, a flower, with two five-pointed leaves, gilded and carved, is set in the red parts of the sloping areas to the left and right. An openwork decorative creeper, with a voluted form and surrounding a long oval medallion with a cherub, appears at the upper extremity.

The background of the icon is gilded beyond the horizon of the landscape and has a chased creeper design. Above the horizon the towers of a fortified town appear. The undulating country is painted greyish-green; the ground formation is suggested by a series of horizontal bluish strokes. The King's daughter kneels below the town with her hands raised to her breast in prayer; she wears a crown on her flowing hair. The picture is dominated by St George on a dapple-grey horse, which is standing with its hind quarters on the scaly back of a dragon while its prancing forequarters are poised above the monster's head. Beneath his red cloak George wears a coat of mail with facial masks on the shoulders. The plume of the helmet consists of one silver and two green feathers. With his lowered right arm he thrusts a short spear into the jaws of the dragon. The talons of the creature claw into the ground, which is depicted as a damp shore beside a lake. The hand of God blesses the knight from a circular segment of sky. The ornamental arrangement of the landscape, the skin of the dragon and the sloping shore show elements of folk art which give the icon a touch of naive charm.

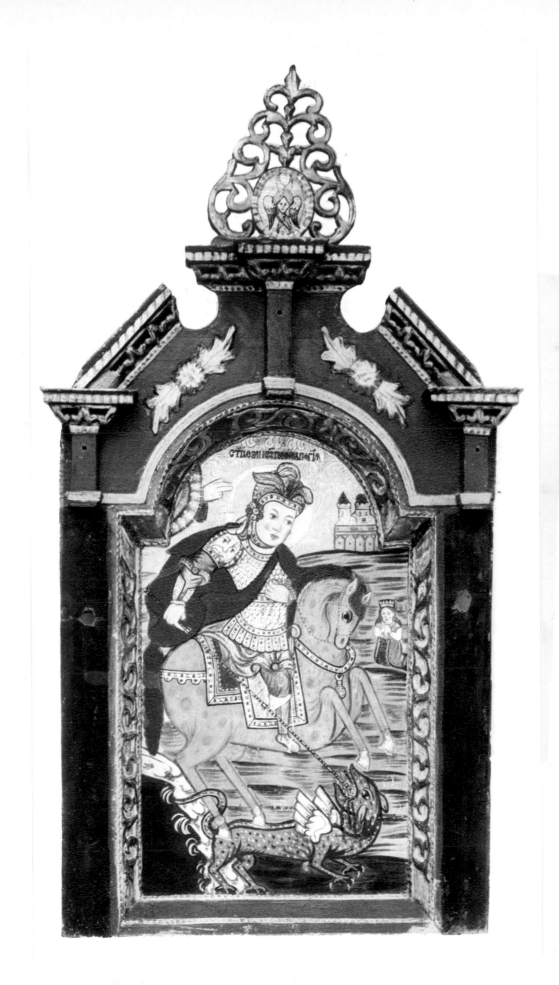

53

ST LUKE THE EVANGELIST

1638.

Wood, 84 × 51 cm.

WOODEN CHURCH IN TROČANY.

In comparison with other portrayals of the Evangelists, this one is striking in that St Luke does not dominate the whole composition. This is largely due to the imposing architecture and the vivid colours of the icon. The many-storeyed towers with their countless windows, doors and battlements, in rich blue and faded red set a definite colour emphasis, which is heightened still further by the luscious green field with its rich carpet of white and red flowers. The richly intertwined and intricate creeper decoration in the golden background has a disturbing effect and drowns the palish colours of the Evangelist's robes. St Luke is sitting at the narrow end of a white table; a blue cloth with decorative white embroidery lies on it and almost touches the ground. This cloth swings inwards in an unmotivated way in order to leave room for the horns of an ox—the emblem of the Evangelist. The ox is lying by Luke's footrest on the brown flagstones, the white joints of which are clearly marked. Their reddish surface with dark-brown strokes suggests a marbled effect rather than an ornamentation. On the table one can see a penknife and a silver pen holder with two quills. In the upper left corner of the picture a space has been left for a white area of sky edged with bluish clouds; here the dove is depicted symbolising the Holy Ghost. A group of rays shines down on the Evangelist from the clouds, their points ending in a thin silvery strip with the inscription of St Luke, written in the usual abbreviated way.

The painting is separated from the wide frame by a narrow golden moulding. In the four corners and in the centre of the four sides of the blue frame there is a simple decoration consisting of oval knobs between two points; these ornamental shapes in relief are gilded and simulate precious jewellery; their metal clasps are here imitated by lively white painted creepers. In the top border the title inscription is repeated; in the lower border the date of the picture is written in large Church Slavonic capital letters: 1638.

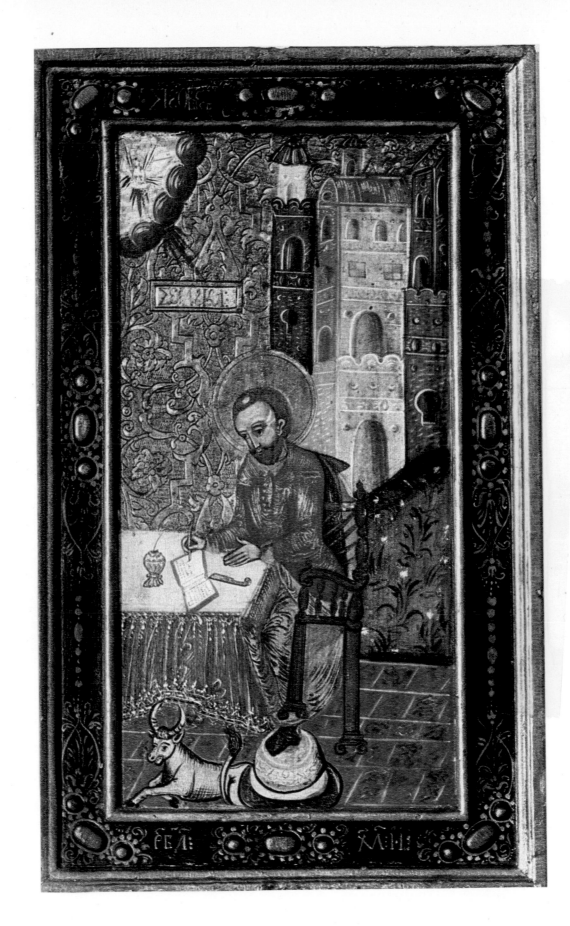

54

ST PARASKEVI, MARTYR

Mid-17th century.

Wood, 119 × 96 cm.

WOODEN CHURCH OF OUR LADY, DOBROSLAVA.

After the death of her Christian parents, St Paraskevi—whose name means Friday—lived in retreat as an ascetic. Later she set out for Italy, preached the Christian faith in Rome and in the countryside, and was imprisoned and beheaded after a succession of tortures at the command of Emperor Antoninus (AD 86 — AD 161). In the Eastern Church she enjoyed great respect as the patroness of commerce and the patroness of all women. The central area of the icon shows the martyr preaching. Over her earth-coloured garment she wears a cloak, the red colour of which alludes to martyrdom, while the white lining is a symbol of chastity. Her left hand holds the cross, which is the symbol for the reason of her martyrdom. The landscape is stylised in a series of green hills. The individual scenes in the central area and below contain events from the life of the Saint before her work in Rome; the marginal ones show her martyrdom and death. They are as follows: 1–3) Her birth, baptism and parting from her parents; 4) Her retreat (the inscription mentions a cave, and the artist has borrowed the raven, who brings food for the Saint, from the iconography of Elijah); 5) Her departure for Italy; 6) St Paraskevi quarrels with the Emperor; 7) She is whipped and 8) thrown into prison; 9) She is lead in chains to the trial; 10) At her appearance the graven images tumble down and are shattered; 11) She is cast into a cauldron full of boiling oil; 12) She is chained to a column and slashed with knives; 13) She is tortured with a saw; 14) The Emperor gives orders for her to be killed by the sword, and 15) She is beheaded.

6				11
7				12
8				13
9	4		5	14
10	1	2	3	15

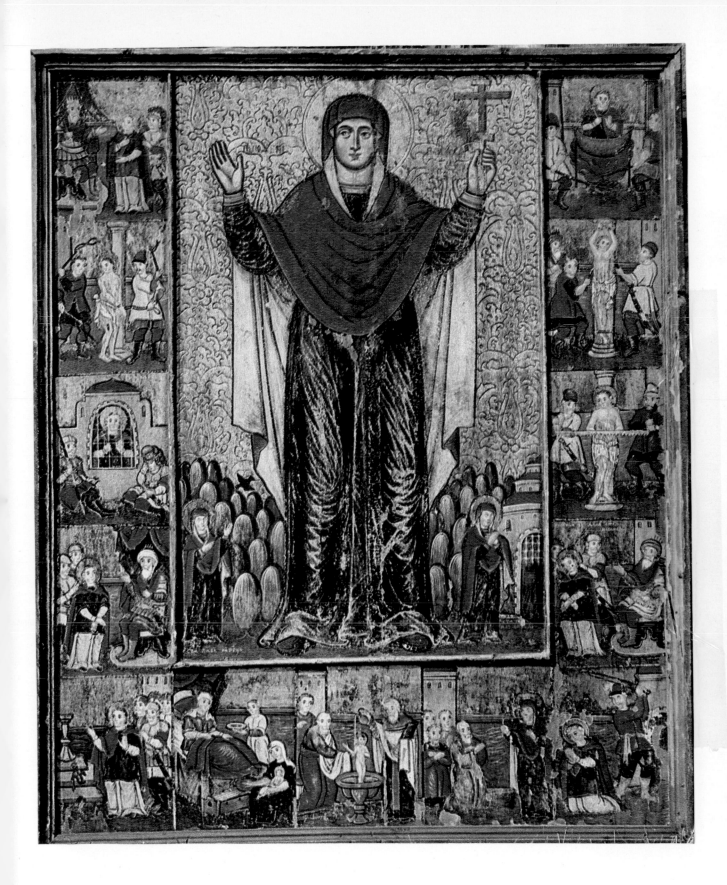

THE JAWS OF HELL

Detail from the Icon of the Last Judgment.

Second half of the 17th century.

Wood, 276 × 185 cm (dimensions of the whole panel).

WOODEN CHURCH OF OUR LADY, DOBROSLAVA.

Only a fragment remains today of the once large icon of the Last Judgment in the Church in Dobroslava. Damaged by shells in the Second World War, it now stands leaning against the southern part of the Iconostasis as a sort of memorial. It was precisely the subject-matter of the Last Judgment that gave artists' imagination a free rein, and this is especially the case with the particulars of hell and its chastisements. This detail shows the right lower corner of the picture, in which the jaws of hell are depicted. The monster's black head, speckled with white dots, shows long, sharp, curving teeth in its mouth. It is puffing out fiery smoky vapours from its pig-like snout. On its head, below the eyes, sits a black-winged, shaggy-tailed devil, with claws and a ram's head; he is blowing into a tuba, the infernal counterpart of an angel's trumpet, calling the dead from their graves to judgment. The Prince of Hell, larger than the devil and with a bull-like head, out of whose mask-like, grotesque face luminous eyes and white teeth show up, is sitting in the gaping jaws of hell and fiercely clutches a figure in his lap; this figure is normally taken to be Judas Iscariot. Fettered in black chains, groups of sinners are dragged into the fiery current, as well as individual sinners guilty of execrable crimes, with the malignant rich man at their head, chained to an iron rack. To the left a group of citizens moves along, the women in low-necked dresses and necklaces, the men with black hats and cloaks. Above this fiendish monster, and in front of a red strip of fire, a devil guards over the innumerable damned. In the upper part of the picture one can see the awakening and raising of the dead from their graves. In the construction of these details the artist shows a drastic and expressive quality, and his exaggeration acquires some elements of caricature.

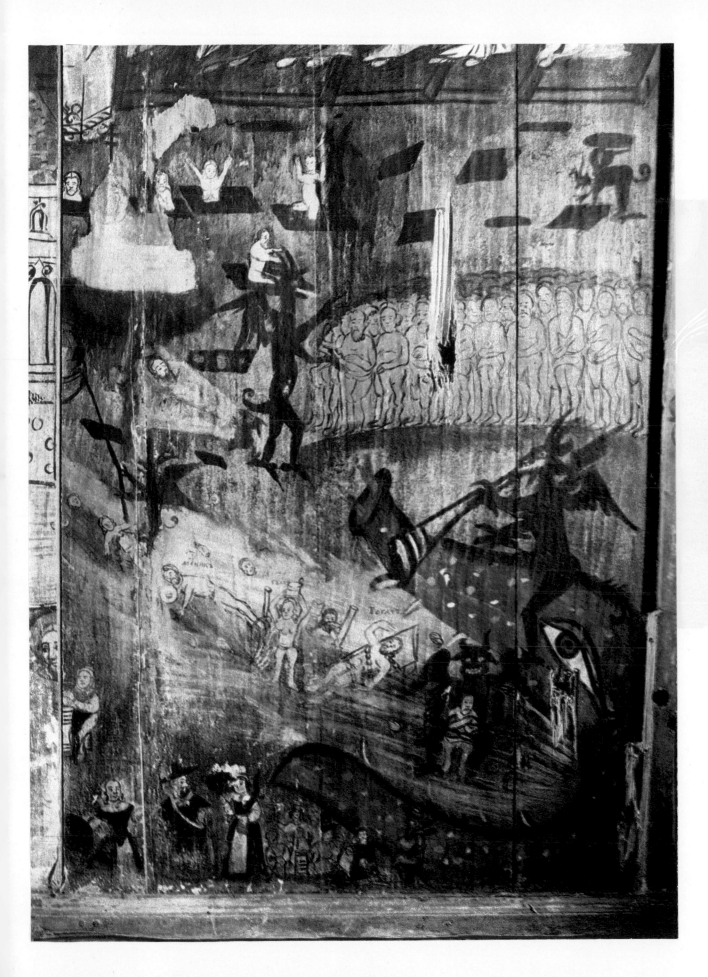

56

THE ARCHANGEL MICHAEL

End of the 17th century.

Wood, 75 × 72 cm.

WOODEN CHURCH IN KRAJNÉ ČIERNE.

The Archangel Michael is considered the Patron Saint of house and home and thus also the Patron Saint of towns. The artist here has aimed at portraying him in the latter capacity.

Michael stands on a white cushion which forms two loop-shaped points and has a design of black and red stripes with large tassels at each end. He is standing at the edge of a craggy ridge with sparse undergrowth. Over his long-sleeved doublet he wears a gleaming silver coat of mail; his cloak falls well down over his shoulders. Both his arms are bent sideways and raised. In his right hand he holds his unsheathed sword menacingly pointing upwards, while his left hand holds the sheath. Michael's head is round, and his hair, parted in the centre, falls in long tresses on to his shoulders. Chin, cheeks, eyelids and temples are reddened. White ribbons hang from the lobes of his ears intended to indicate, symbolically, his constant readiness to follow divine instructions. His green and white feathered wings soar above the town and landscape in the background, likewise a symbol of his protection. Beyond the crags, on which Michael is standing, the ground falls away steeply down to a river; the far bank is flat and sandy. An undulating green area borders this bank with sheaf-like humps, similar to those which form the landscape background in the icon of St Paraskevi in Dobroslava (plate 54). Over this fertile area appear a large stone church or monastic institution and a walled town on the other side, behind which a huge tree with a flat crown of foliage can be seen. The fields stretch as far as the horizon and whitish-grey clouds float across the sky. The Archangel affords this world calm and security, keeping injustice at bay. This inner relationship between patron and ward is emotively presented by the artist, who tends to a stylisation and simplification of formal expression. An icon with a similar theme differing only in immaterial details, and probably by the same artist, is to be found in the Church at Mirol'a (Cat. of the Slovak National Gallery, Bratislava, No. 56, plate 59).

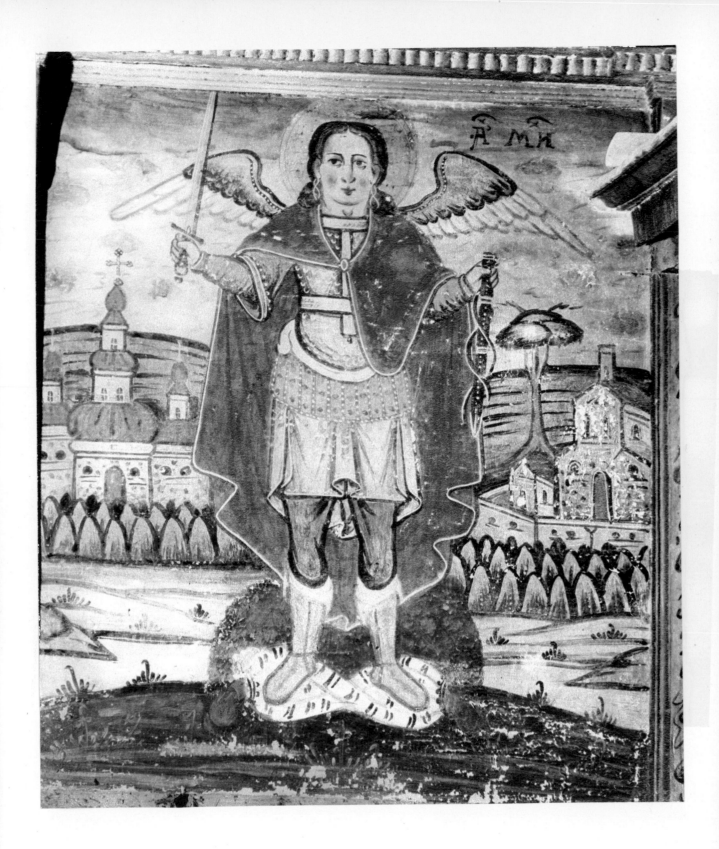

THE ASSEMBLY OF THE ARCHANGEL MICHAEL

Beginning of the 18th century.

Wood, 110 × 71 cm.

CHURCH OF THE ARCHANGEL MICHAEL, ULIČSKÉ KRIVÉ.

The frame of this icon slants inwards and has a simple design of irregular whitish-grey brush dabs on a red background. The painting is rounded off in the upper part and the curve of the arch is framed with a gold moulding. A large carved gilded rosette is set in the corners of the green spandrels.

The golden background of the icon, with finely chased creeper decoration, is only partly visible beneath the clouds surrounding God the Father, due to the fact that the haloes of the host of angels who are pressing round the Archangel Michael reach as far as the edge of the clouds. God Zeboath holds a white globe in his left hand, while his right hand is stretched out in blessing. The inscription of the picture has only been partially preserved: *SOBOR ARCH* (Assembly of the Archangel Michael). Dressed in armour with a red cloak over his shoulders, Michael holds an orb in both hands in front of his chest, on which Christ Emmanuel, the young Christ, is depicted. The two angels beside him each hold a small orb, on which 'holy' and 'the Lord' are written on the left and right respectively in the usual abbreviated version. To emphasise his majesty, Michael is standing on a white cushion with two points and black stripes, which is lying on the tiled floor. The faces of the first row of angels behind him are clearly distinguishable, but the angels in the distance are suggested merely by a multitude of haloes and shapes of hair. The treatment of the faces recalls remotely the icon of St John of Suceava (plate 49). But in this icon a far greater simplification of formal expression is identifiable.

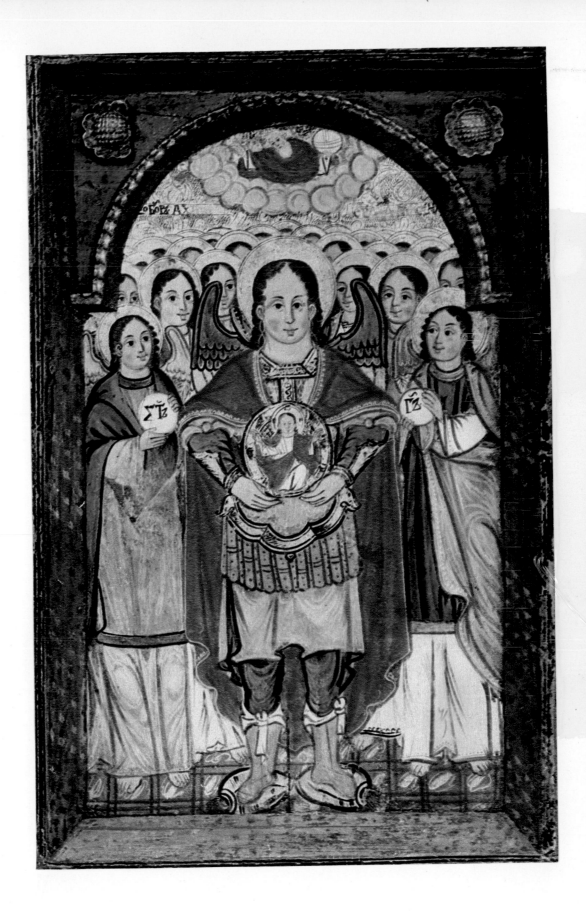

THE ASCENSION

Beginning of the 18th century.

Wood.

WOODEN CHURCH OF BASIL THE GREAT, KALNÁ ROZTOKA.

It is apparent that some of the icon painters in the Carpathian region also painted murals and ceilings when it was required. One is reminded of this when looking at the Festival Icons on the wall of the Church in Kalná Roztoka. Despite the small size of the icons, the figures have a monumental quality and, by renouncing all detail, the artist achieves a dynamic and full statement. He uses iconographic tradition freely and boldly. For him it is simply a reminder, which he varies according to the feelings of piety of his time. Nothing remains of the sacerdotal construction of the old icons of the Ascension of Our Lord, showing the Redeemer borne to Heaven by the angels in an aureole and a group of Apostles standing round the Virgin. In this icon everything is portrayed more intimately, and the distance between heaven and earth is narrowed down. The clouds are almost at ground level, shrouding the figure of Christ, whose arms are outstretched in blessing. Mary's hands are raised and clasped in prayer; the Apostles' arms are crossed over their chests. One of them has both hands raised and seems to be clutching at the clouds. And not only are the Apostles present here, but also some people from the environs, kneeling down likewise. One cannot escape from an impression that the artist has borrowed some of the gestures from the iconography of the Ascension of the Prophet Elijah, such as the raised-up arms of one of the Apostles, which remind one of the attitude of Elisha, catching hold of Elijah's coat. Christ's bearing also recalls Elijah. The artist seems merely to have left out the reins of the fiery chariot held in his hands. In the hands of this artist, then, an icon of Christ's Ascension has become more of a devotional picture, expressing his personal feelings.

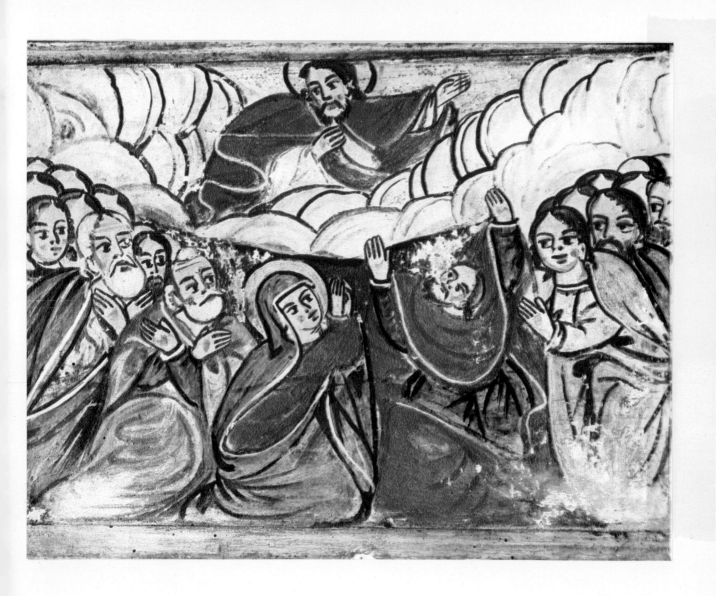

59

THE MAN OF SORROWS

1706.

Wood, 36,5 × 22,5 cm.

WOODEN CHURCH OF THE ARCHANGEL MICHAEL, BODRUŽAL.

The Man of Sorrows is a particularly popular theme in all art forms in the Carpathian region, and his portrait hangs in many a church on the sacrificial altar-piece in the northern corner of the chancel, as for example in Bodružal. A simple gilded frame surrounds the painting, the gold background of which is decorated with large finely chased creepers and zigzag lines. The background consists of an architectural scene; the walls of the buildings are covered with a pattern of irregular strokes and spirals. The lines of the tiles are well defined on the red roof above the portal. Christ is sitting on a six-cornered stool, which, in form, follows the background architecture. The upper part of his body is naked and traces of the lash are visible on his chest and arms. His fettered hands are resting on a red cloak wrapped around his hips. He is not wearing a crown of thorns, and the sign of the cross does not appear in his halo. The date of the icon is written in heavy white capital letters on the brown foreground: *IN THE YEAR OF OUR LORD 1706.*

РОКᲣ БЖІ Ã ᲃ S.

THE ADORATION OF THE CHILD

From the Festival Series of the Iconostasis in the wooden Church at Príkra.

Mid-18th century.

Wood.

WOODEN CHURCH, PRÍKRA.

In the late icons from the Carpathian region the simplification of the theme was often heightened by a conscious borrowing from the painter's own environment; this small icon from the Festival Series of the Iconostasis is a typical example. The Adoration of the Child has here become a delightful village idyll. The Virgin is sitting holding her Child on a white cushion in front of the vestibule, which is simple, beamed and straw-roofed. At her feet stand the ox and ass, gazing up at the Christ Child. Joseph stands behind Mary, behind the balustrade of a slightly raised vestibule; he is wearing a fur-trimmed cloak. Two shepherds have entered the house. They are wearing broad-brimmed hats, white apparel with red embroidery and brown shoes with red laces. The clothes correspond to the dress of the painter's time. The foremost shepherd is playing a flute, the other carries a lamb by the legs over his shoulder. A red-robed angel floats above the shepherds in a white cloud, holding a white ribbon in both hands, on which an irregular dark line suggests the tidings of the angel on Christmas Day. A pale blue sky stretches across the whole scene. A simple gold frame surrounds the icon, which is bordered by a bright red outer stripe.

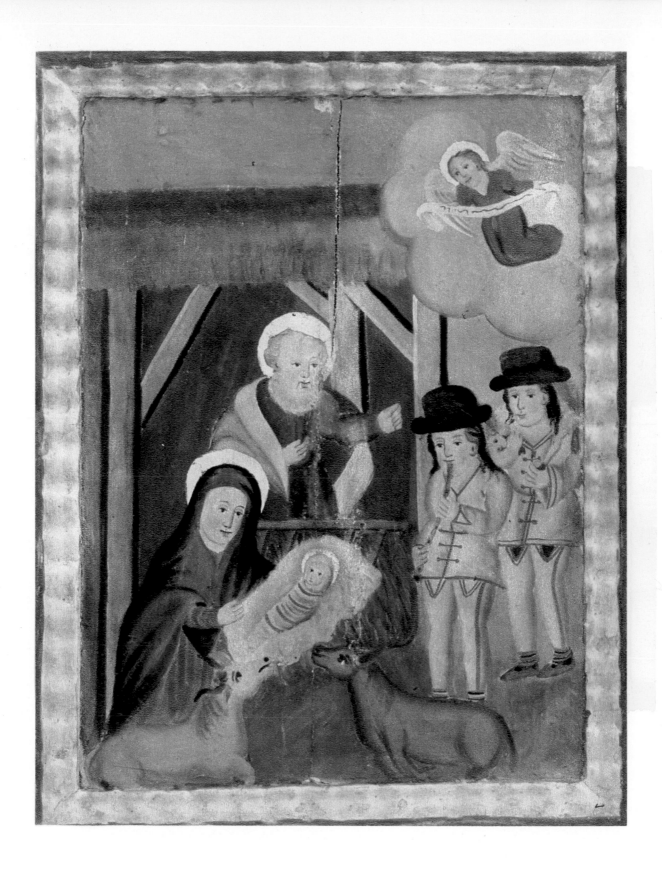

ICONS IN CZECHOSLOVAKIA

● places mentioned in the notes to the plates

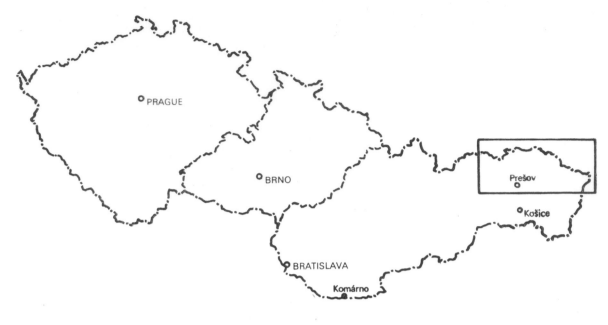

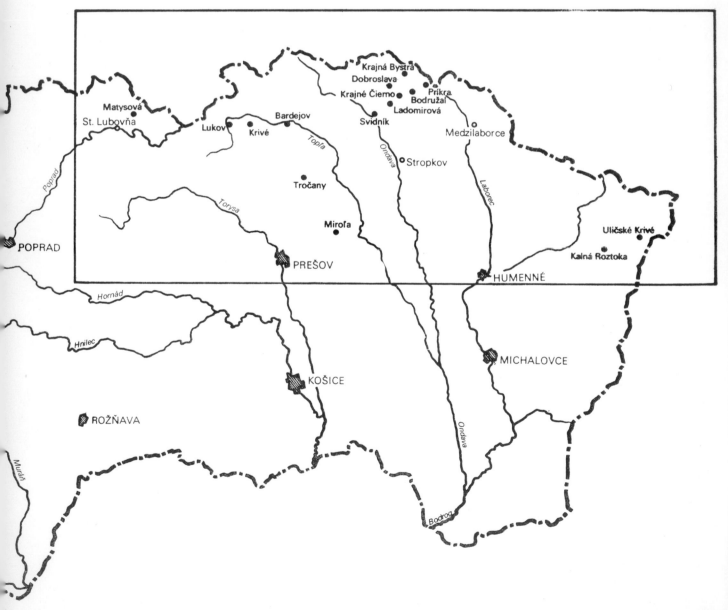

BIBLIOGRAPHY

ENGLISH

Anisimov, A. I.,	Our Lady of Vladimir.	Prague, 1928
Bank, A. V.,	Byzantine Art in the Collections of the U.S.S.R.	Leningrad – Moscow, 1966
Beckwith, J.,	The Art of Constantinople.	London, 1961
Bolshakova L., and		
Kamenskaya, E.,	State Tretyakov Gallery, Early Russian Art.	Moscow, 1968
Dalton, O. M.,	Byzantine Art and Archaeology.	Oxford, 1911
Dalton, O. M.,	East Christian Art.	Oxford, 1925
Farbman, M., (editor)	Masterpieces of Russian Painting. (Text by Anisimov, Sir Martin Conway, Roger Fry and I. Grabar)	London, 1931
Hamilton, G. H.,	The Art and Architecture of Russia.	London, 1954
Jamschikov, S.,	Old Russian Painting, Recent Discoveries.	Moscow, 1955
Johnstone, P.,	The Byzantine Tradition in Church Embroidery.	London, 1967
Kondakov, N. P., and		
Minns, E. P.,	The Russian Icon.	Oxford, 1927
Lazarev, V. N.,	Novgorodian Icon Painting.	Moscow, 1969
Lazarev, V. N.,	Old Russian Murals and Mosaics.	London, 1966
Loeschke, W.,	Icons: Apostles and Evangelists.	London, 1967
Panofsky, E.,	Studies in Iconology.	London, N. D.
Rice, D. Talbot,	The Icons of Cyprus.	London, 1937
Rice, D. Talbot,	Byzantine Painting, The Last Phase.	London, 1968
Rice, T. Talbot,	Icons.	London, N. D.
Rice, T. Talbot,	Russian Icons.	London, 1963
Schroder, A.,	Introductions to Icons.	London, 1967
Schweinfurth, P.,	Russian Icons.	London, 1953
	UNESCO World Art Series, U.S.S.R.: Early Russian Icons.	1958
	Russian Icons – the Collection of George R. Hann. Carnegie Institute.	Pittsburgh, 1944
Voyce, A.,	The Art and Architecture of Medieval Russia.	Norman, Oklahoma, 1967

FRENCH

Alpatov, M. V.,	Trésors de l'art russe.	Paris, 1966
Blankoff, J.,	L'art de la Russie ancienne.	Brussels, 1963
Bozhkov, A.,	L'école de peinture de Triavna.	Sofia, 1967
Delvoye, Ch.,	L'art Byzantin.	Paris, 1967

Embiricos, A.,	L'école crétoise, dernière phase de la peinture byzantine.	Paris, 1967
Grabar, A.,	La peinture byzantine.	Geneva, 1953
Grabar, A.,	La peinture religieuse en Bulgarie, 2 volumes.	Paris, 1928
Iorga, N.,	Les arts minieurs en Roumaine, 2 volumes.	Bucarest, 1934/36
Millet, G.,	L'art byzantin chez les Slaves, 4 volumes.	Paris, 1930/32
Millet, G.,	L'iconographie de l'Evangile.	Paris, 1916
Mouratoff, P.,	L'ancienne peinture russe.	Paris, 1925
Mouratoff, P.,	Les icônes russes.	Paris, 1928
Mouratoff, P.,	Trente-cinq primitifs russes.	Paris, 1931
Myslivec, J.,	Deux icônes italo-grèques de la collection Soldatenkov, Seminarium Kondakovianum, VII.	1935
Ouspensky, L.,	Essai sur la théologie de l'icône dans l'Eglise Orthodoxe, volume 1.	Paris, 1960
Radojčić, S.,	Icônes de Serbie et de Macédoine. (3rd edition: Munich, 1962)	Belgrade, 1961
Weidlé, W.,	Les icônes byzantines et russes.	Florence, 1950
Wild, D.,	Les icônes, Orbis pictus I.	Lausanne, 1947

GERMAN

Alpatov, M. V.,	Altrussische Ikonenmalerei.	Dresden, 1958
Bozhkov, A.,	Die bulgarische Malerei von den Anfängen bis zum 19. Jahrhundert.	Recklinghausen, 1969
Bröker, G.,	Ikonen.	Leipzig, 1969
Felicetti-Liebenfelds, W.,	Geschichte der byzantinischen Ikonenmalerei.	Olten-Lausanne, 1956
Gerhard, H. P.,	Welt der Ikonen.	Recklinghausen, 1957
Glück, H.,	Die Christliche Kunst des Ostens.	Berlin, 1957
Grabar, A.,	Byzanz. (Kunst der Welt)	Baden-Baden, 1964
Grabar, A.,	Die mittelalterliche Kunst Osteuropas. (Kunst der Welt)	Baden-Baden, 1968
Grabar, I., Lazarev, V. N., and Demus, O.,	Frühe russische Ikonen. (Unesco World Art Series)	Munich, 1958
Hackel, A. A.,	Das Altrussische Heiligenbild, die Ikone.	Nijmegen, 1936
Hare, R.,	Tausend Jahre russische Kunst. (English edition: Art and Artists in Russia, London 1965)	Recklinghausen, 1964
Hutter, I.,	Frühchristliche Kunst – byzantinische Kunst. (Belser Stilgeschichte, IV)	Stuttgart, 1968

Kornilowitsch, K.,	Kunst in Rußland von den Anfängen bis zum ende des XVI. Jahrhunderts.	Munich-Geneva-Paris, 1968
Lebedeva, J. A.,	Andrei Rubljow und seine Zeitgenossen.	Dresden, 1962
Myslivec, J.,	Ein Betrag zur Ikonographie der russischen Heiligen, Byzantinoslavica IV.	1932
Onasch, K.,	Die Ikonenmalerei. Grundzüge einer systematischen Darstellung.	Leipzig, 1968
Onasch, K.,	Ikonen. (English edition: London, 1961)	Gütersloh, 1961
Onasch, K.,	König des Alls.	Berlin, 1954
Ouspensky, L., and *Lossky, V.,*	Der Sinn der Ikonen.	Berne–Olten, 1952
Papageorgiou, A.,	Ikonen aus Zypern.	Munich–Geneva–Paris, 1969
Schweinfurth, Ph.,	Geschichte der russischen Malerei im Mittelalter.	The Hague, 1930
Skrobucha, H.,	Die Botschaft der Ikonen. (English edition: Icons, London, 1963)	Ettal, 1961
Skrobucha, H.,	Meisterwerke der Ikonenmalerei (French edition: Merveilles des Icônes, Paris, 1969)	Recklinghausen, 1961
Skrobucha, H.,	Von Geist und Gestalt der Ikonen. (English edition: Introduction to Icons, New York, 1965)	Recklinghausen, 1961
Rice, D. Talbot	Byzantinische Kunst.	Munich, 1964
Rice, D. Talbot	Die Kunst im byzantinischen Zeitalter.	Munich–Zürich 1968
Rice, T. Talbot	Die Kunst Rußlands.	Munich, 1965
Rice, T. Talbot	Russische Kunst (Phoenix Pocket, 40)	Zeist, 1960
Volbach, W. F., and *Lafontaine-Dosogne, J.,* *Weitzmann, K.,*	Byzanz und der christliche Osten (Propyläen Kunstgeschichte, Volume 3)	Berlin, 1968
Chatzidakis, M.,	Frühe Ikonen: Sinai, Griechenland, Bulgarien, Jugoslawien.	Vienna–Munich, 1967
Miatev, K., Radojčić, S., *Wendt, C. H.,*	Rumänische Ikonenmalerei.	Eisenach, 1953
Wild, D.,	Ikonen.	Bern, 1946
Wulff O., and *Alpatoff, M.,*	Denkmäler der Ikonenmalerei.	Hellerau bei Dresden, 1925
Wulff, O., and *Alpatoff, M.,*	Ikonenkatalog, National Museum, Berlin.	Berlin, 1967